MEDWAY & SWALE SHIPPING
SHIPPING
THROUGH TIME

Geoff Lunn

AMBERLEY PUBLISHING

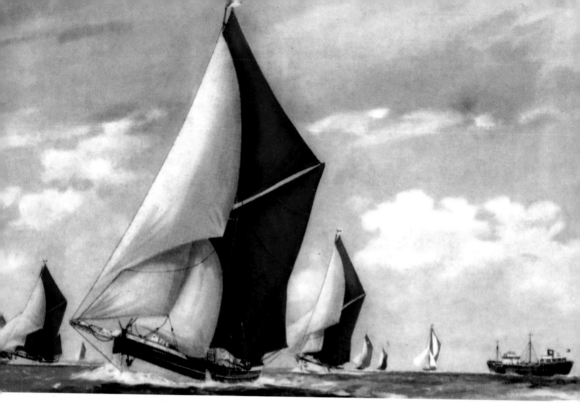

Medway and Swale recalled

The spritsail Thames barge *Cabby* creates a splendid picture as she contests with other competitors during a barge race. Built at Strood in 1928 and a prominent entrant in the annual Medway Barge Match, she symbolizes the history of the Medway and Swale, recalling the days when hundreds of sailing barges were built to serve the various industries that occupied the riverbanks, wharves and creeks.

First published 2012

Amberley Publishing
The Hill, Stroud
Gloucestershire, GL5 4EP

www.amberley-books.com

Copyright © Geoff Lunn, 2012

The right of Geoff Lunn to be identified as the
Author of this work has been asserted in accordance
with the Copyrights, Designs and Patents Act 1988.

ISBN 978 1 4456 0625 5

British Library Cataloguing in Publication Data.
A catalogue record for this book is available from
the British Library.

Typeset in 9.5pt on 12pt Celeste.
Typesetting by Amberley Publishing.
Printed in the UK.

Introduction

The River Medway and the Swale, Kent's main commercial waterways, both possess fascinating histories that envelop invasion from abroad, maritime disasters and the development and demise of various trades and industries. The Medway flows in a north-easterly direction from its Sussex source in the Ashdown Forest, on a journey of some seventy miles before entering the estuary of the River Thames. The Swale, which was originally part of a river itself, runs predominately eastwards, linking the Medway's estuary with the north Kent coast at Whitstable and dividing the Isle of Sheppey from mainland Kent.

The Medway is not only considerably longer than the Swale, but much deeper, allowing ships of ocean-going proportions to venture upriver as far as Chatham. River traffic on the Swale has always been restricted in size to barges and small coasters, but its importance to this corner of England cannot be undervalued. The region's natural resources led to the creation of two important local industries during the nineteenth century. Cement works and brickworks grew in number and in stature over the next decades, using mud and clay dug from the lower Medway, quarried chalk and, for the making of bricks, sand. By the turn of the century as many as twenty-six cement factories populated the banks of the Medway from Burham to Rainham, smoke from their lofty chimneys billowing up into the darkened skies. The 1850s also saw the birth of a third major industry in north Kent: paper manufacturing. Mills were constructed at Snodland, and later at Aylesford and Sittingbourne, all three, albeit under different ownership and guises, remaining in business to this day.

Raw materials for the three industries needed to be conveyed by river and the River Medway and the Swale would be inundated with barges and short-sea ships bringing in their cargoes as far as the tides would allow. Finished products and goods from agricultural Kent would be transported in the opposite direction. Hundreds of barges

and other small vessels were built in the region to meet this demand, but nowhere was shipbuilding as prevalent as at the dockyards of Sheerness and, in particular, Chatham. Once King Henry VIII had nominated the Medway as the perfect safe haven for his nation's battle fleet, the river's connections with the Royal Navy were assured. The first record of Chatham Dockyard emanates from 1547, while just over a century later Sheerness Dockyard was born. Of more than 300 ships built at Chatham, Nelson's HMS *Victory* was undoubtedly the most famous, but as ship construction turned from wood to iron and steel, formidable battleships and cruisers were sent down the ways, together with fifty-seven submarines.

Sadly, Sheerness Dockyard closed in 1960 and stringent defence cuts enforced the demise of Chatham Dockyard in 1984. These were bleak days for the region, but a thriving commercial port now operates on the Sheerness site. At Chatham the former dockyard has become three separate entities: Chatham Maritime, a housing and business project with marina facilities; Chatham Docks, a commercial enterprise handling short-sea cargo ships; and Chatham Historic Dockyard, a working museum that celebrates the dockyard's history and which has received heritage status.

In many ways the regenerated Chatham Dockyard represents the modern-day Medway and Swale. Working docks and wharves have mainly given way to residential and business property and leisure facilities, while privately-owned motor cruisers and yachts have replaced the sailing barges, tugs and lighters of yesteryear. A large proportion of the Medway's trade is now handled at downriver berths, close to its estuary. Opposite Sheerness, on the Isle of Grain, which was once the site of Europe's largest oil refinery until its closure in 1984, a container terminal has developed and grown since its inception in 1990 and is now capable of receiving ships of at least 90,000 gross tons. Called, rather curiously, Thamesport (although well within the bounds of the Medway) it is independently owned and operated, unlike Sheerness and Chatham docks which are under the control of Medway Ports, part of the Peel Ports group. Medway Ports act as the harbour, pilotage and conservancy authority for 27.3 navigable miles of tidal river from Medway Buoy downstream to Allington Lock near Maidstone, including Queenborough Harbour and Faversham and Milton Creeks on the Swale.

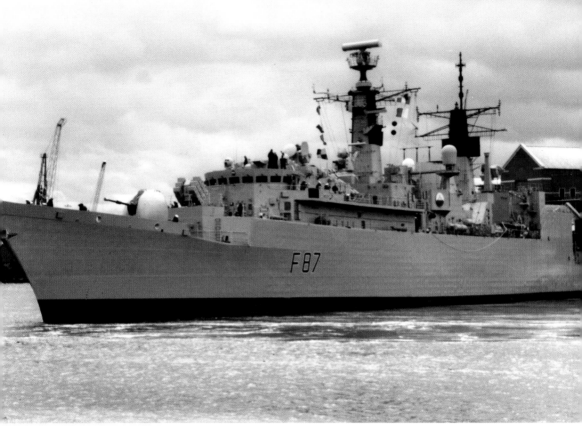

Historic Connections

The River Medway and the British navy were virtually synonymous for centuries. But as their connection grew increasingly tenuous HMS *Chatham* makes one of her last visits to her namesake town. The 5,300 ton frigate, commissioned in May 1990, paid off from service in February 2011 amid much sadness.

CHAPTER ONE

The River Medway – From Maidstone to Rochester

We begin our journey through time down the River Medway at Maidstone, which emerged as an important Medway port in the early 1800s when numerous wharves along its riverbanks handled barge traffic. By the end of that century, however, most of the lower Medway's trade had been diverted to rail and, like today, its lock gates were opened mainly for pleasure craft. North of Maidstone, Allington Lock marks the beginning of the river's tidal waters, while less than a mile upstream the Medway passes through Aylesford Bridge, built from Kentish ragstone in medieval times and later adapted to create more headroom for river traffic.

From here the Medway winds to and fro, forming the occasional pronounced loop, cutting through the north Kent chalk as it heads towards Rochester. This was once the most industrialised stretch of the river, but little commerce now remains. Its paper mills rely on road transport, while the final chimney of the final cement works was demolished at Halling in 2010.

With the ancient crossing at Rochester Bridge in sight, the river is traversed by the more expansive Medway Bridge, which consists today of three separate structures. The eastern bank, now lined with residential property, is where the three brothers Short moved their seaplane works from Eastchurch on the Isle of Sheppey in 1914, producing the world's most famous flying boats until the business transferred to Belfast in 1948.

Rochester Bridge proved an obstacle for the movement of manufactured cement downriver and woodpulp for the paper industry upriver, and off Strood, Frindsbury and Rochester, where shipbuilding and cement and gas works used to prevail, freighters would moor in line, offloading pulp into lighters for further shipment up the Medway. Today, just a single shipping line operates its own pulp and timber wharves as the river here gradually silts up.

MAIDSTONE.

Painting Different Pictures

An early twentieth-century Maidstone river scene, reproduced in water colour. A working sailing barge is moored against the quayside while a lone oarsman approaches Archbishop's Palace. Barge fleets operating from Maidstone upriver to Tonbridge evolved during the eighteenth and nineteenth centuries, transporting stone, gravel and lime and bringing back agricultural products from the Weald. Today, with the emphasis on leisure and pleasure, passenger boats run daily

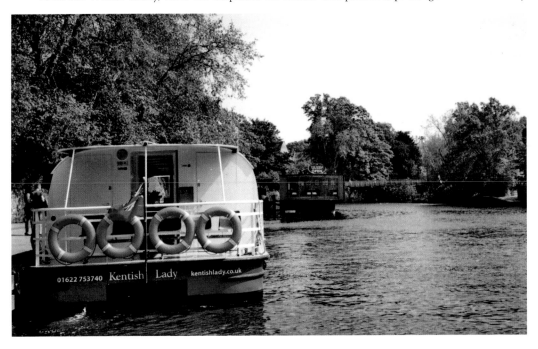

01622 753740 Kentish Lady kentishlady.co.uk

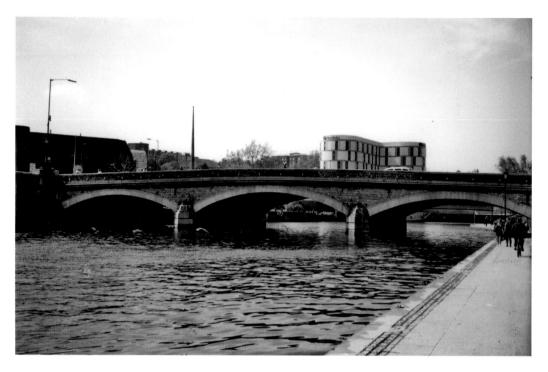

Crossings Old and New

Maidstone's Town Bridge, built in 1879 to replace a fourteenth-century bridge, has changed little over the years apart from widening work in 1927 and its neighbouring architecture. Although river traffic has decreased, Maidstone's road traffic has multiplied, influencing the 1976 opening of St Peter's Bridge, seen on the right, just downstream from its older partner.

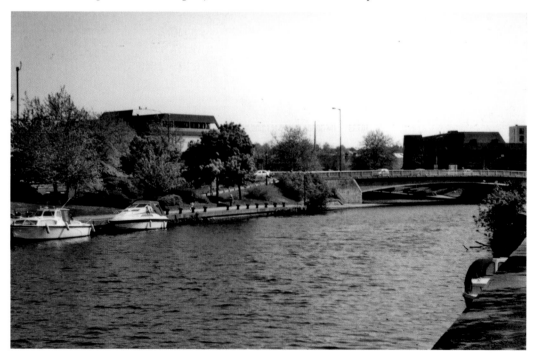

Changing Riverbanks

A small boat approaches the high level Maidstone East Railway Bridge, built in 1874 and reconstructed in 1926. Between this bridge and the old Town Bridge fifteen wharves once served Maidstone's brewing, flour and timber industries. Today, residential apartments and retail outlets form a backdrop to privately-owned cruisers on the river.

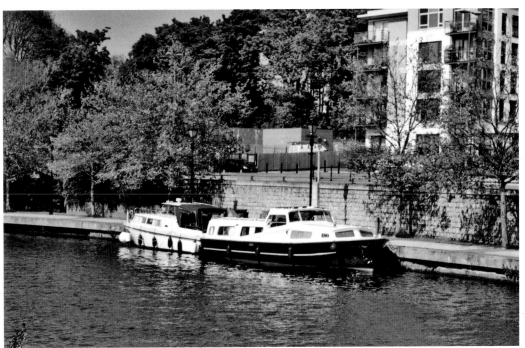

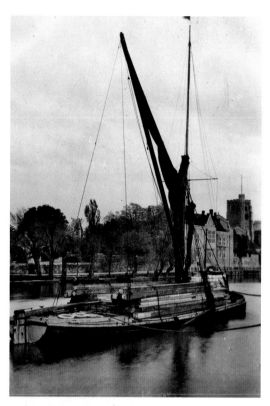

Sailing Barge Memories
Laden with timber, a spritsail barge evokes
memories of bygone years at Maidstone.
Although barge traffic has long disappeared
from the Medway, these memories have been
rekindled by the opening of a 'barge restaurant'
at a nearby quay.

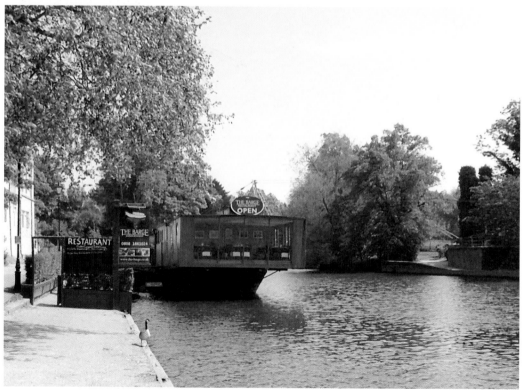

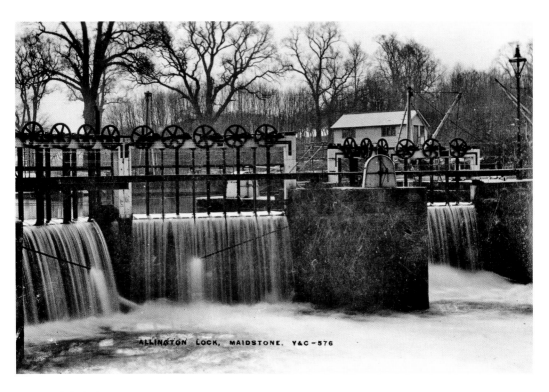

ALLINGTON LOCK, MAIDSTONE. Y&C-576

Tidal Limit

Allington Lock, the beginning of Medway navigation, around 1930, prior to the completion of the present lock in 1939. Close by, Allington Sluice, pictured in the company of a variety of small boats, has recently received a £2.7 million renovation.

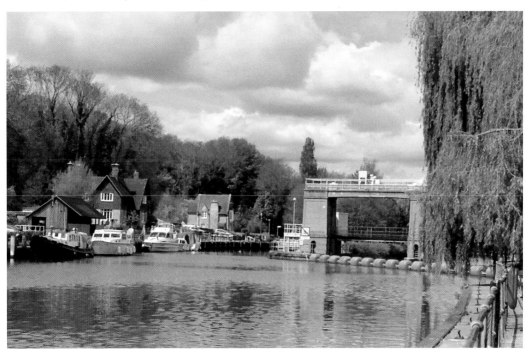

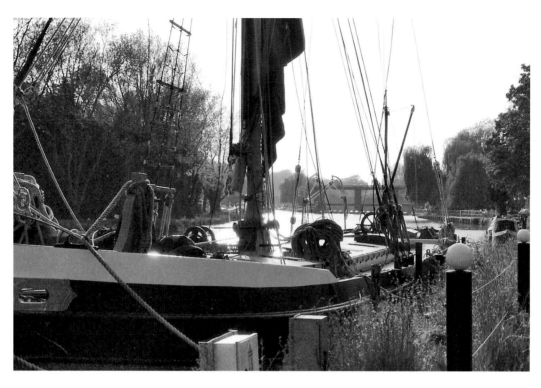

Upriver Boats
Where sailing barges would pass to and from Maidstone and Tonbridge, little motor boats moor peacefully in this lovely stretch of river near Allington.

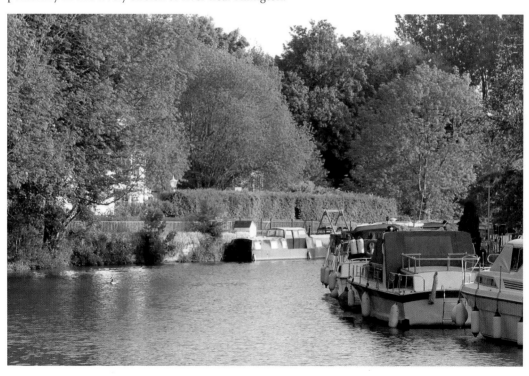

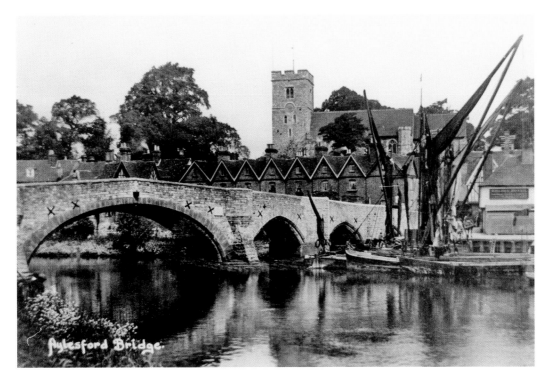

Setting in Stone

The River Medway at Aylesford was first bridged in 1370 and the second structure presents a peaceful setting in our hectic modern world. In fact, today's picture is similar to that of a century or so ago, when sailing barges would tie up at the village wharf.

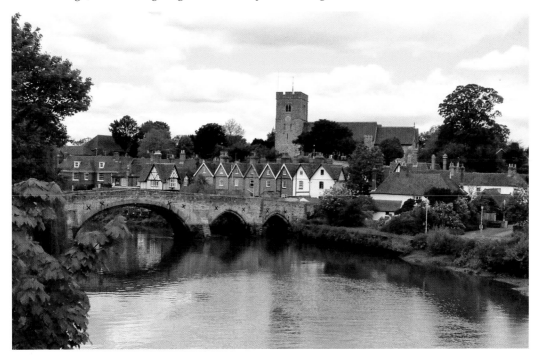

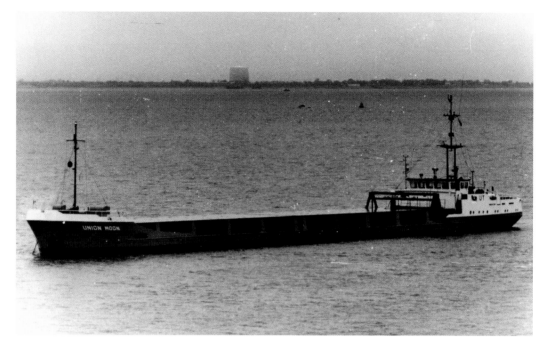

Cementing the Past

Ships with low air draft telescopic bridges, such as *Union Moon*, built 1985/1,543 gross tons, were able to negotiate the arches of Rochester Bridge on their upriver journey to Rugby Cement's Halling Wharf. Very little now remains of the cement works, demolition of its lofty chimney in 2010 marking the end of 150 years of the cement industry in the area.

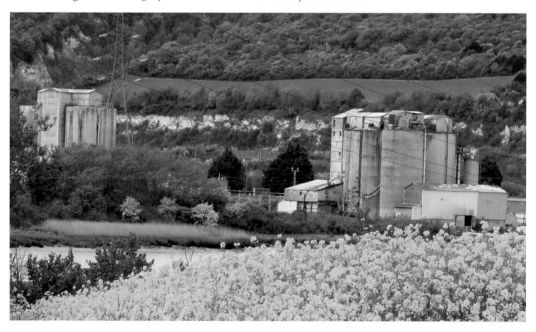

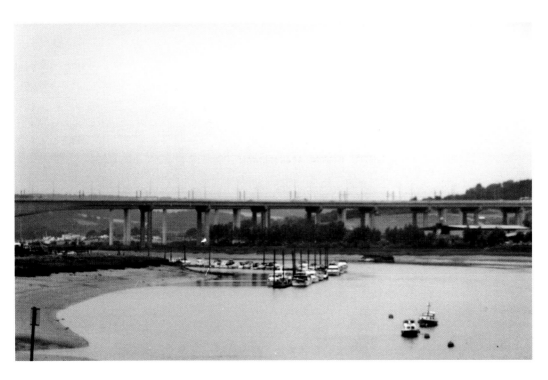

Spanning the Medway
The imposing Medway Bridge, completed as a single structure to carry the M2 motorway in 1964, but since extended into three separate structures with the addition of a second motorway bridge and a high-speed rail bridge.

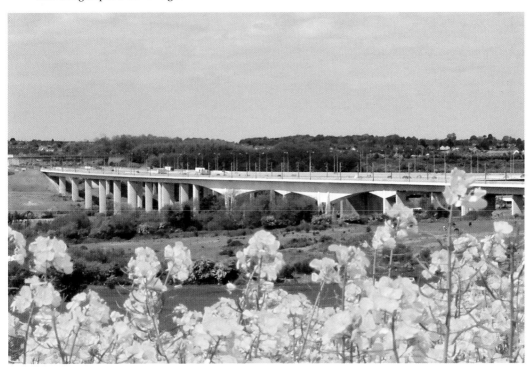

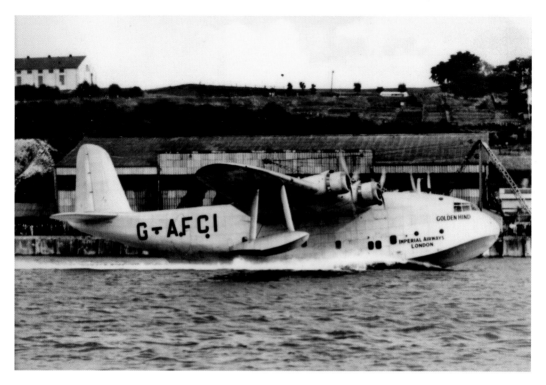

First Flight

Short Bros' G-AFCI *Golden Hind*, the first of three large S.26 transport flying boats, passes the company's Rochester Esplanade works on its maiden flight on 21 July 1939. After Short's moved to Belfast the site was taken over by engineering firm Hobourn Aero, but residential property now occupies much of the Esplanade.

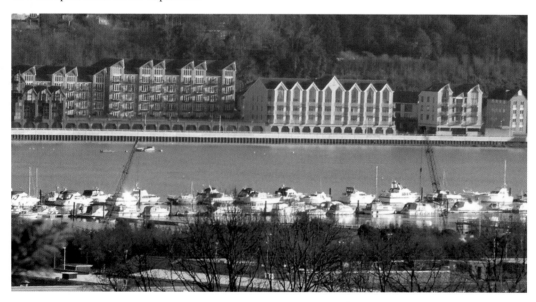

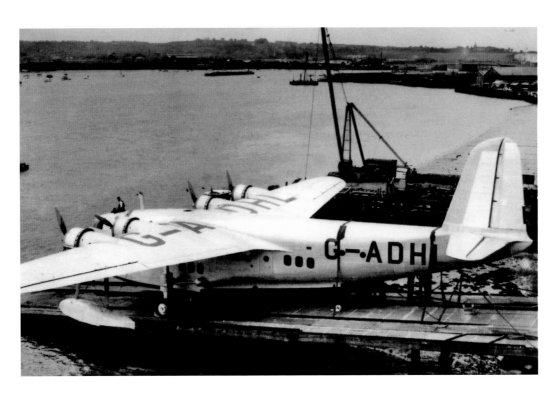

River Launch

Canopus, an Imperial Airways flying boat, waits on the launching ramp outside No 3 erecting shop of Short's factory. The ramp, albeit rusted and overgrown, remains as a memento of those pre-war days.

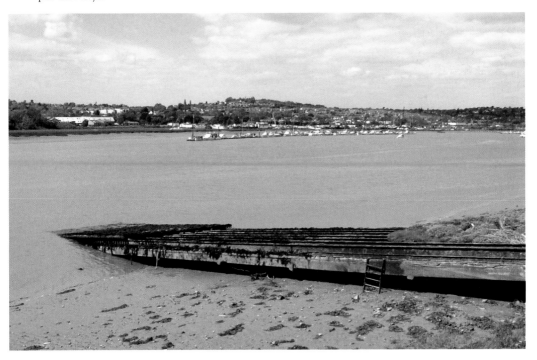

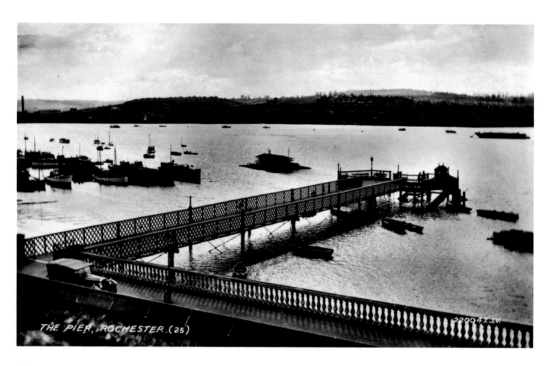

Pier Improvements

Rochester Pier, situated immediately upstream from Rochester Bridge, has been improved over recent years with the addition of covering and a landing stage for the comfort and safety of river excursion passengers.

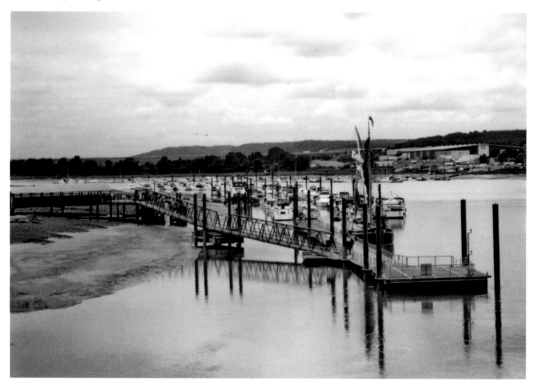

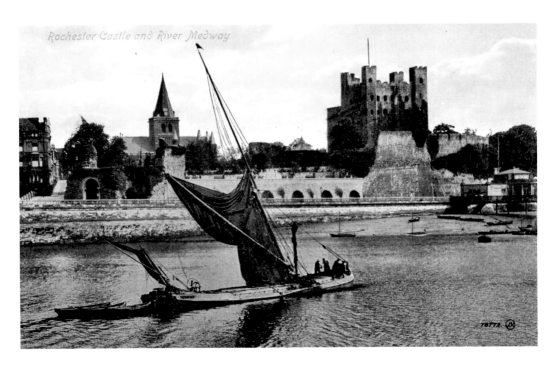

Rochester Castle and River Medway

From Barges to Motor Cruisers

A sailing barge passes Rochester's Castle and Cathedral after 'shooting' Rochester Bridge. The three boats astern indicate there is a 'huffler' aboard. 'Hufflers' assisted the barge crews to lower their masts and gear in order to pass under, or 'shoot', a bridge and to wind them back again afterwards. Today, although the backdrop is almost the same, small leisure craft have replaced the working barges.

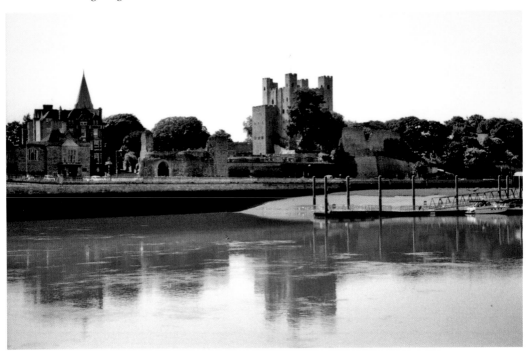

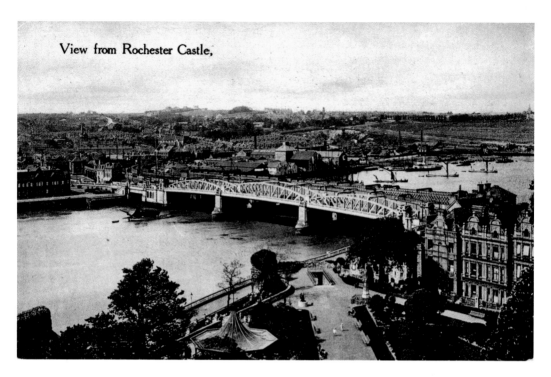

View from Rochester Castle.

An Ancient Crossing

Rochester Bridge, completed in 1856, replaced a medieval structure that had stood since 1392. Note the paddle steamer, sailing barges and cement factory chimneys in the above picture, taken soon after 1914 when the bridge was heightened to aid river navigation. The bridge is notably wider nowadays, a second roadway having been added in 1971.

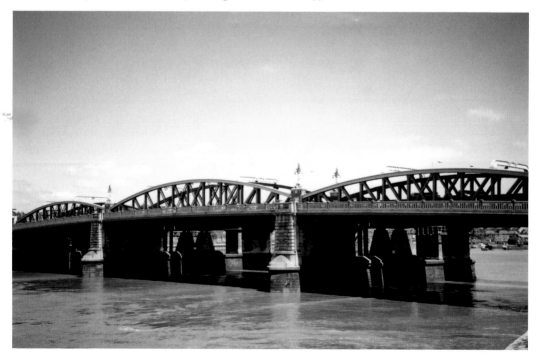

Awaiting her Fate

Shipbreaking was another Strood industry and in 1979 the Isle of Man passenger ferry *King Orry*, 1946/2,485grt, arrived to be scrapped by Lynch & Son. Her ending could hardly have been more ignominious, having broken away from a berth in a Lancashire dock amid a severe storm in 1976 and spending over three months aground before being brought to the Medway.

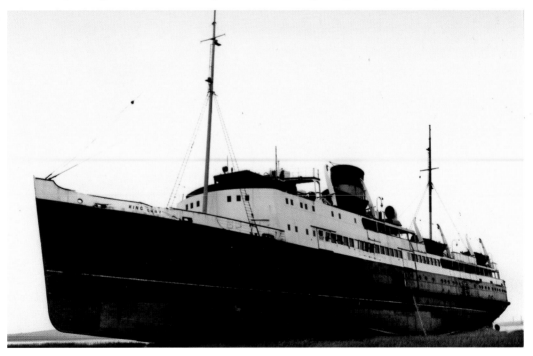

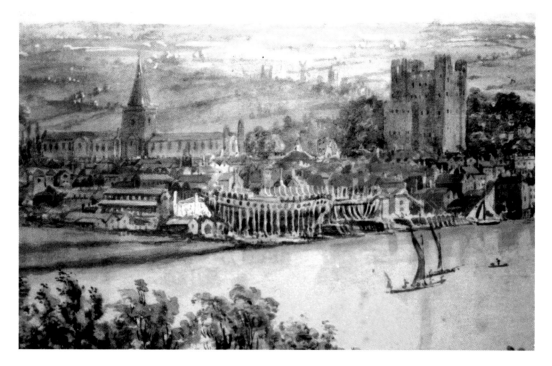

Historic Shipyard

Looking across to Rochester from Frindsbury, around 1812. The skeletons of warships on the stocks at Acorn Wharf are in evidence. Under the ownership of Charles and Mary Ross, the wharf built a number of ships for the Royal Navy, posing short-term competition for Chatham and Sheerness dockyards. A shipyard still exists to this day for the repairing of small coasters.

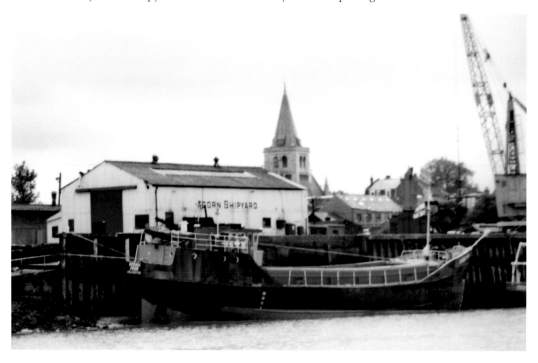

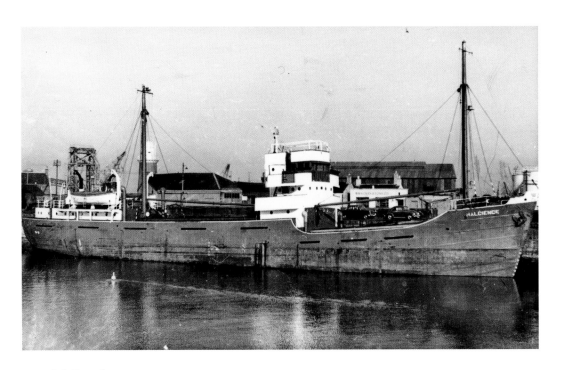

L & R to Crescent

The London & Rochester Trading Company based its offices at Strood for many years, progressing from a local sailing barge owner to an operator of a large fleet of coastal cargo ships. *Halcience*, 1949/994grt, was one of their larger motor ships, while the shallow draft single decked *Function*, seen here adapted for the conveyance of sand and ballast, was one of a series of much smaller fleet members. London & Rochester became Crescent Shipping during the 1980s and was later sold to the Hays Group.

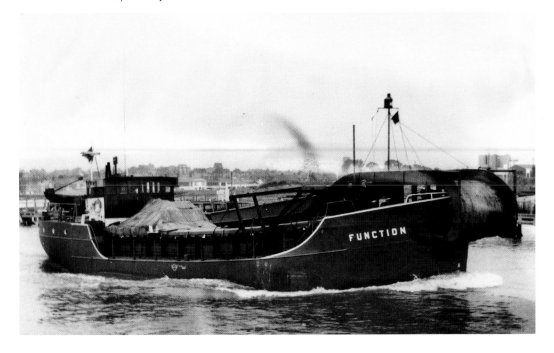

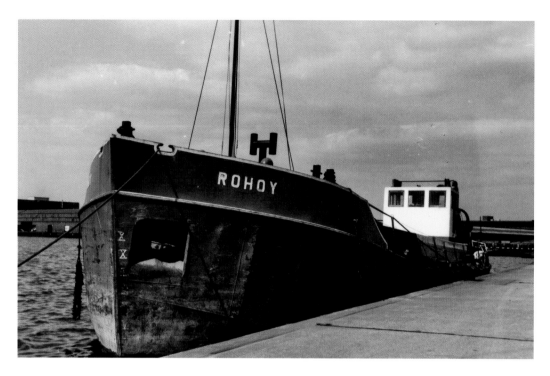

Frindsbury Shipyards

London & Rochester owned the Quarry Yard at Frindsbury, where they built several coastal motor barges in the 1960s. One of these was *Rohoy*, 1966/172grt. The yard closed in 1998 but ship repair continues at Frindsbury where Thames pleasure craft, including Gravesend-based *Princess Pocahontas*, are overhauled in the winter months.

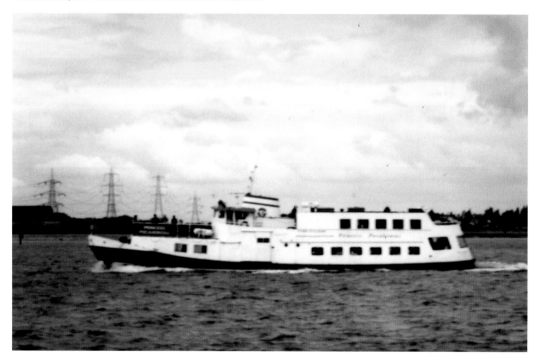

Diamonds of the Past

The newly completed sand suction dredger *Sand Harrier*, 3,751grt, offloads at Cory's Wharf during the early 1990s. Cory's own colliers, also sporting the diamond on their funnels, would serve Rochester's gasworks in preceding decades, but now the once-busy wharf is gone, apart from a single crane, as further development is planned.

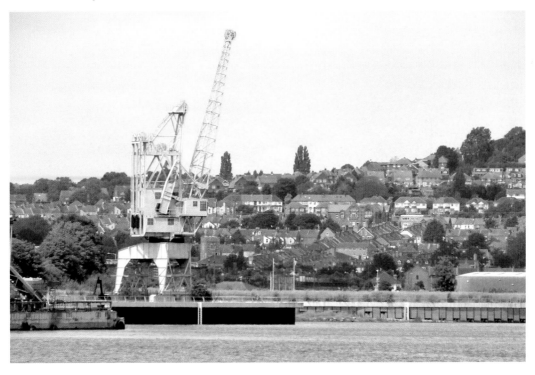

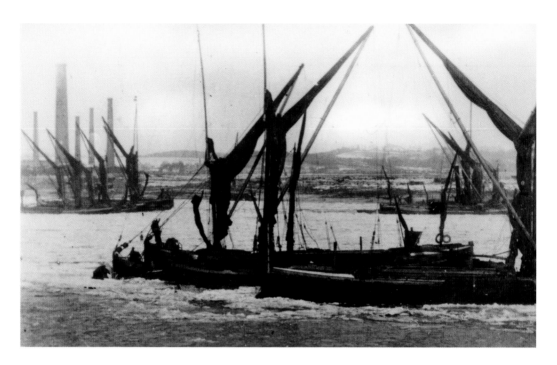

Ice-age Cement
Spritsail rigged sailing barges icebound at Rochester in February 1895. To the left, behind them, are the chimneys of the Crown & Quarry Cement Works, which closed in 1962. There were no less than seven riverside cement works at Frindsbury, but over recent decades a busy industrial estate has developed on the Frindsbury Peninsula, which is being passed by the inward-bound coaster *Steel Sprinter* during the 1990s.

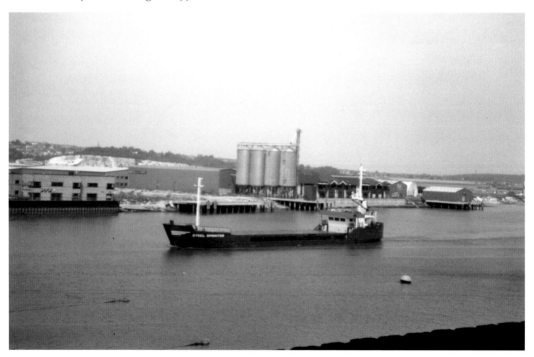

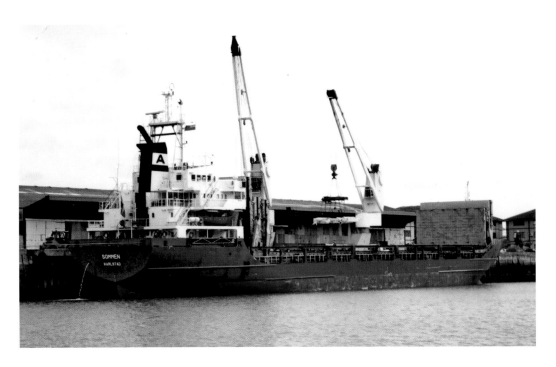

A Swedish Friend Moves On

For many years the 4,426grt *Sommen*, owned by Ahlmark Lines AB, would call at Transit Wharf on the Frindsbury Peninsula, until leaving the route early in 2011 when she was renamed *Mar Bianco*. At the same time the wharf was taken over by Scotline to supplement their neighbouring facilities, where their vessel *Scot Ranger*, 1997/2,260grt, is berthed.

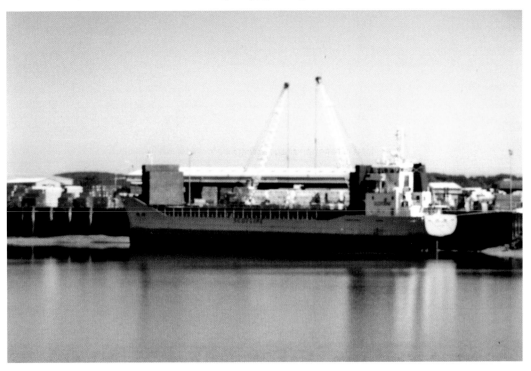

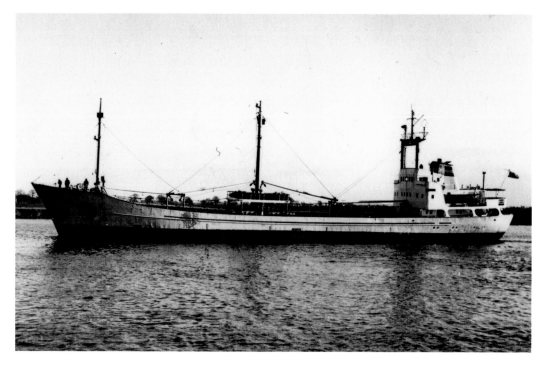

Rochester Locals

During the nineteenth century Thomas Watson began work as a ship's broker in Rochester and his firm later evolved into one of the region's principal owners of coastal cargo ships. The *Lady Sylvia*, 1965/1,000grt, was a typical fleet member. Sadly, Watson's ships are no longer seen at Rochester, unlike Crescent Shipping's little motor barge Roan.

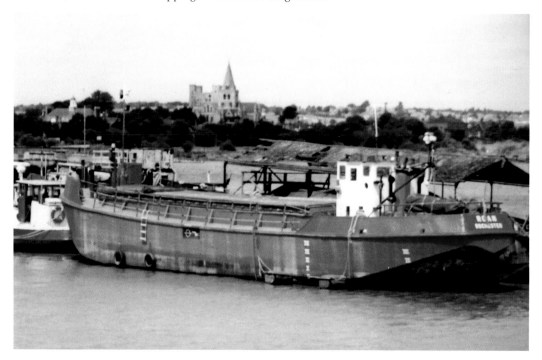

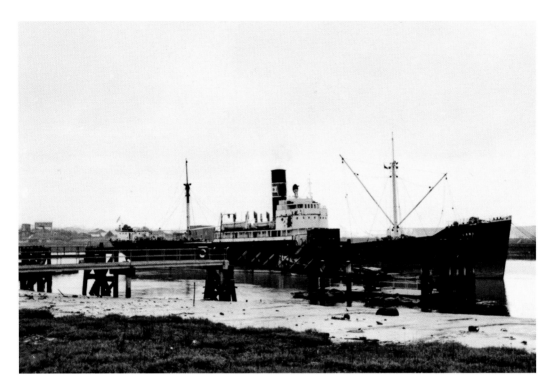

Low Tide in Limehouse Reach
The Liberian-flagged steamship *Lena*, 1948/2,694grt, lies off Ship Pier, a popular route taken by ships' crews on their way to the local drinking houses. Nowadays only a handful of small craft moor in Limehouse Reach and the pier is virtually unused.

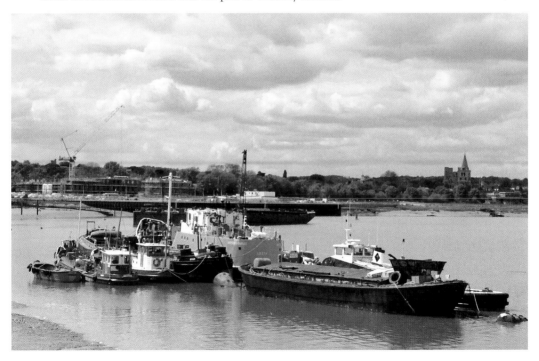

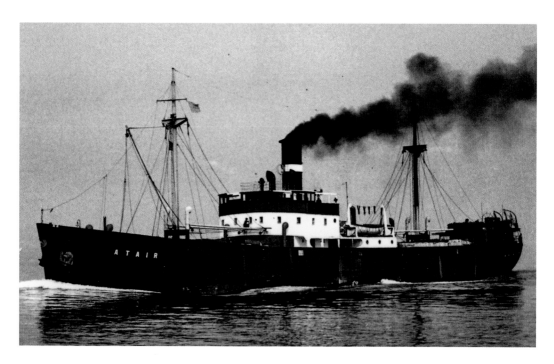

Pulp Ships From Finland

Atair, 1943/1,586grt, was typical of the cargo ships owned by Iris Redeerei of Finland that would discharge their cargoes of wood pulp at Rochester buoys. The handsome *Finnmaster*, 1954/2,136, also hailed from Finland. Note her unusually raked bow, designed to encounter the Baltic's winter ice.

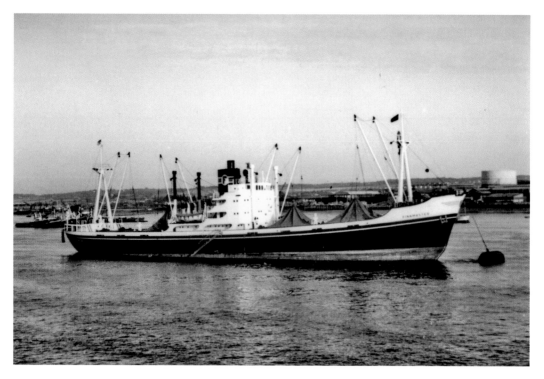

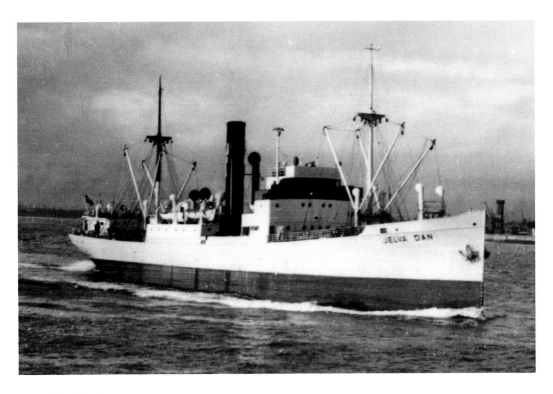

The 'Dans'

Their names bearing the suffix 'Dan', vessels of the large Danish fleet of J. Lauritzen were a regular sight at Rochester. *Jelva Dan*, 2,285grt, dated from 1919 but was still calling in the 1950s. Later fleet members had bright red hulls to match their funnel colours, such as *Silja Dan*, 1951/2,676grt.

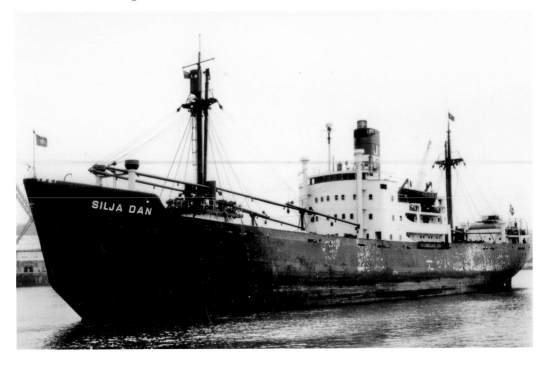

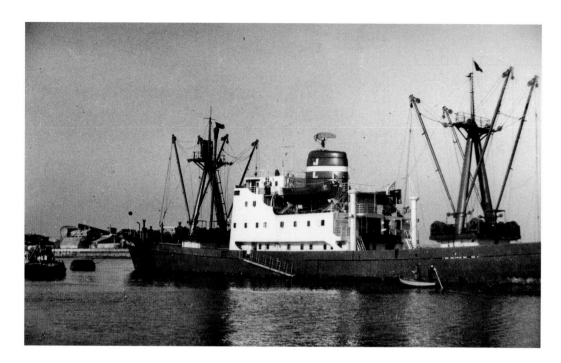

Diverse Designs

One of the last Lauritzen pulp ships to regularly call at Rochester was the 2,641grt *Anita Dan*, built in 1956. She began a new career in 1968 as the Royal Naval ice patrol ship HMS *Endurance*, a role that she served until 1991. As the twentieth century progressed, visiting pulp ships changed in shape and form, many with their machinery and superstructure positioned aft. Eventually shipping ceased to use the buoys, discharging their cargoes at riverside wharves rather than into lighters.

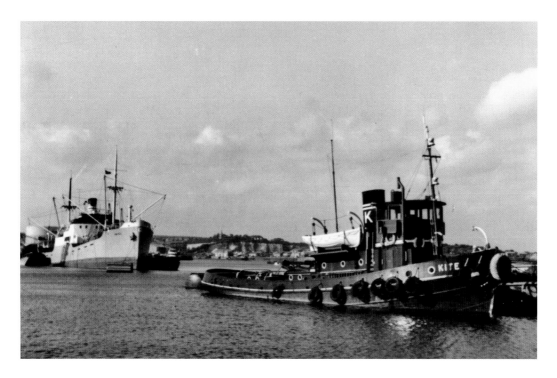

The 'K' Tugs

For many decades most Medway towage work was undertaken by tugs of J. P. Knight Ltd, a local business originating from 1892. Moored off Rochester, ahead of a pulp freighter, is the company's 118grt motor tug *Kite*, built in 1952, while a few years later the 1960-built *Kemsing*, 138grt, is pictured at a nearby location.

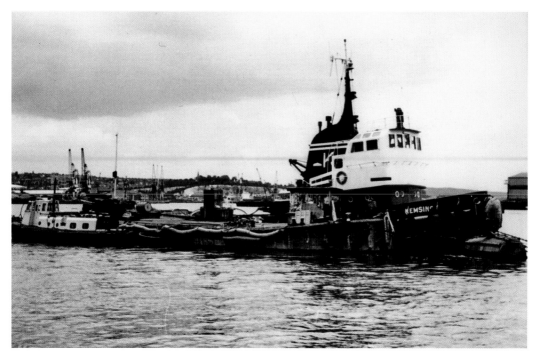

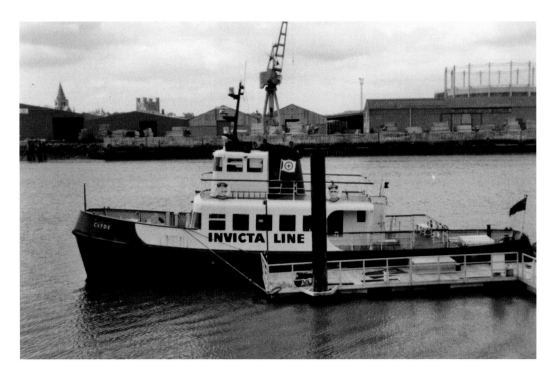

Brief Encounters

For a few years during the 1980s and 1990s local firm Invicta Line Cruises ran summer excursions between Strood, Chatham and Southend, employing the *Clyde*, a converted Clyde Port Authority tug. This was augmented for a while by a river bus service, linking Strood, Rochester and Chatham, operated by a former Norfolk Broads Cruiser, the *Clairest*, before the company folded.

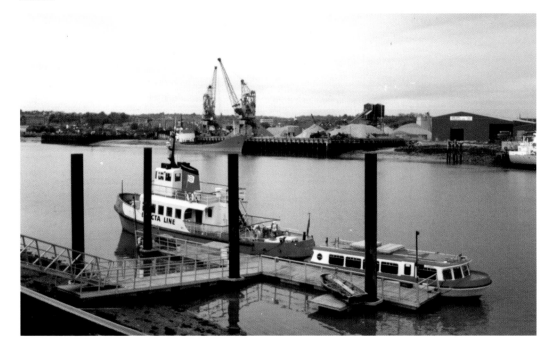

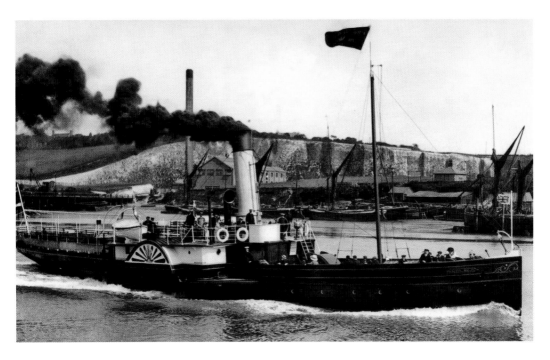

A Princess and a Queen

The paddle steamer *Princess of Wales* steams down the Medway on another excursion to Southend. Built in 1896 for the Medway Steam Packet Company, she gave wartime service with the Admiralty and was broken up in 1928. Her owners became the New Medway Steam Packet Company in 1919 and in 1924 they took delivery of their first ship, the 318grt *Medway Queen*, which would become one of the most popular paddle steamers of her time.

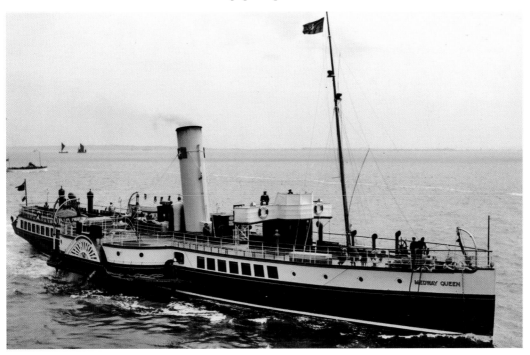

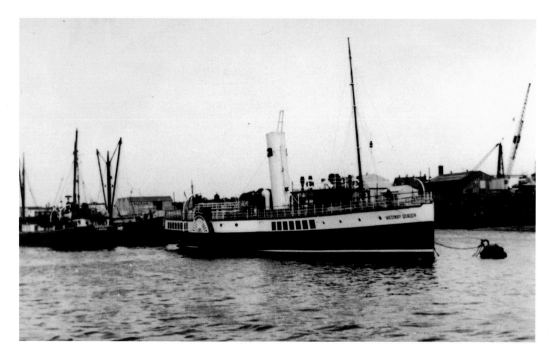

Save the Queen

Medway Queen on her winter break at Rochester. Each summer she would run day trips to Southend, Herne Bay, Margate and Clacton. During the Second World War she took part in the Dunkirk evacuation, bringing home 7,000 servicemen on seven heroic voyages. Retiring from service in 1963, she was sold as a floating hotel but then became a nightclub on the Isle of Wight (below), a venture that soon failed. Following the formation of the Medway Queen Preservation Society she was brought back to the Medway in 1984 and thanks to heritage funding and other donations, her restoration still continues to this day.

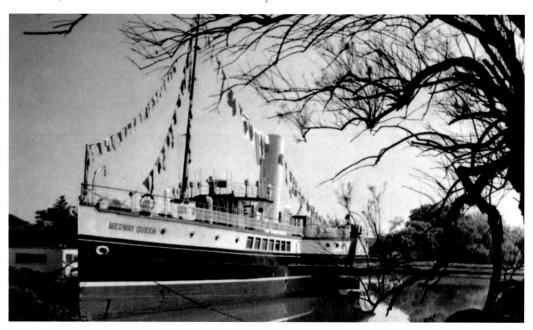

CHAPTER TWO

The River Medway – From Rochester to the Estuary

Heading north from Rochester and Chatham, the River Medway passes the renovated covered slipways and dry docks of Chatham's former naval dockyard. Immediately beyond, on the same eastern side, is St Mary's Island, which was reclaimed as a 380-acre extension to the old dockyard in 1864 but since the yard's closure has been redeveloped with residential property. Nearby, the Bull Nose entrance locks, through which warships of almost every shape and size would pass in bygone years, receive short-sea freighters entering Chatham Docks.

Upnor Castle, which stands tall on the opposite riverbank, was constructed in the sixteenth century as defence for Britain's man-of-war fleet. Unfortunately its chance to prove its worth against the might of the invading Dutch in 1667 drastically misfired, the ships from Holland overcoming the British fleet and capturing many ships, including the jewel of Britain's navy, the *Royal Charles*.

From here onwards, as the Medway's waters enter a quieter stretch of river, wharves are few and far between apart from a bulk carrier berth attached to Kingsnorth Power Station, whose days are numbered following a decision to close down the power station as from 2013. A feature of the lower Medway is its prevalence of creeks where working barges and small coasters would unload their cargoes, especially during the industrial years of local brickmaking. Nowadays these creeks are no longer of commercial significance, although they do offer quiet havens for small boats.

On the western bank of the Medway estuary a small oil refinery was opened by an American entrepreneur in 1923, only to last for nine years. However, in March 1953, Europe's largest refinery began operating on the same Isle of Grain site, commissioned by the Anglo-Iranian Oil Company, which would become British Petroleum in 1954. In the early 1980s the axe fell not only on Chatham Dockyard but also on the Grain refinery, but once again business is booming in the Medway estuary as the Thamesport container terminal continues to expand its quayside facilities and shipping services.

During the past hundred years the River Medway has witnessed three terrible tragedies, costing more than 1,100 lives. Two of these occurred during the First World War and close to the present Thamesport site. On the opposite side of the estuary, Sheerness Dockyard began as a seventeenth-century fortification and was rebuilt in 1813 to partner Chatham's yard in the building and repairing of warships. After its closure, conversion for commercial use was rapid and today it shares with Thamesport a considerable percentage of the Medway's total tonnage. At nearby Garrison Point the Medway enters the Thames estuary where the third maritime disaster to stun the people of north Kent occurred, in 1950.

Chatham View

Looking downriver from Sun Pier, Chatham. These views, almost a century apart, both feature the tower of St Mary's Church, but in the later scene Gun Wharf, once an ordnance depot and loading wharf, is dominated by the modern offices of Lloyd's of London, which are now occupied by the local council.

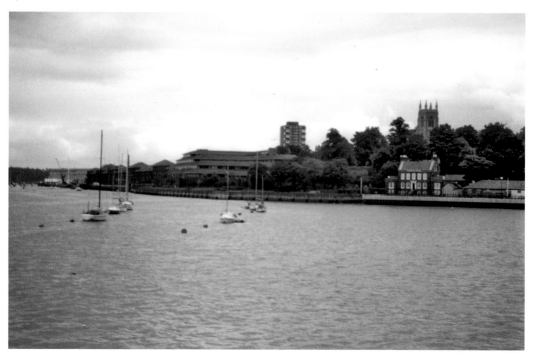

Frindsbury Aggregates
Displaying the funnel markings of ARC Marine, the sand-suction dredger *Arco Adur*, 1988/3,498grt, arrives at Hanson Aggregates' wharf on the Frindsbury Peninsula. Hanson have since swallowed up ARC, whose ships grew in size and number after the locally-named *Arco Swale*, 1970/1,579grt, was in service.

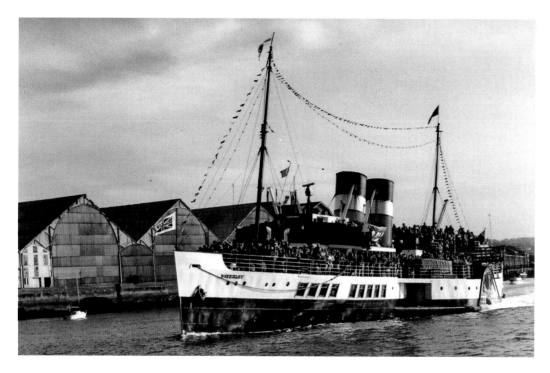

Paddlers Steamers' Liaison

The world's last seagoing paddle steamer, *Waverley*, 1947/693grt, passes the restored covered slips of Chatham Historic Dockyard. Every autumn she meets her little 'sister', *Kingswear Castle*, the Medway's own 'paddler', during her cruising season around Britain's coasts. Both ships were saved from extinction by the Paddle Steamer Preservation Society, *Waverley* in 1974 and the 1924-built *Kingswear Castle* in 1965.

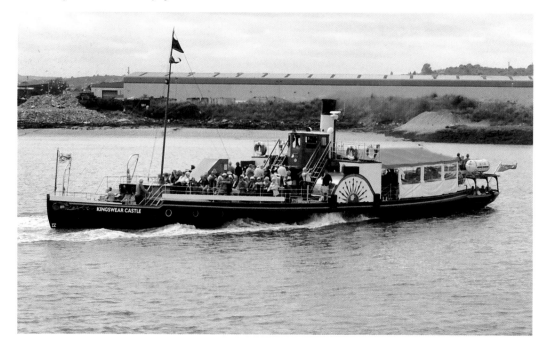

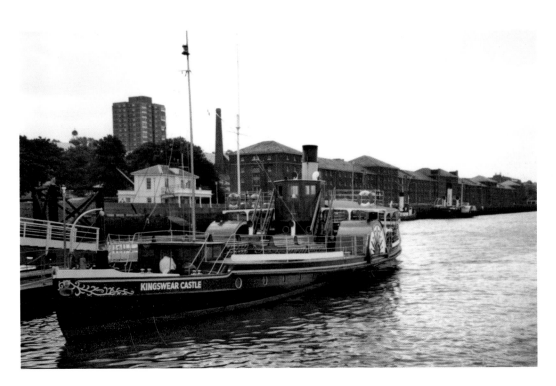

Naval Base

Kingswear Castle, 94grt, at Thunderbolt Pier, her Chatham Historic Dockyard base. Currently the only vessel operating summer excursion seasons on the Medway and Swale, she was built for service on the River Dart. Meanwhile, pictured under the pier's girders, *Waverley* prepares for her next cruise.

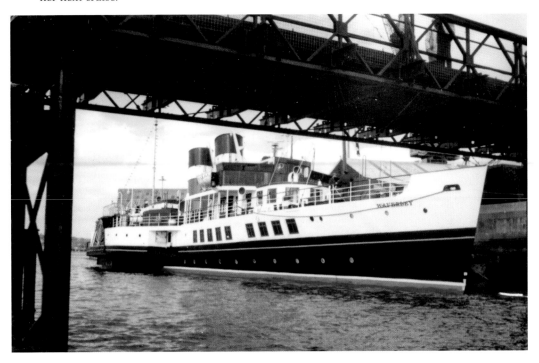

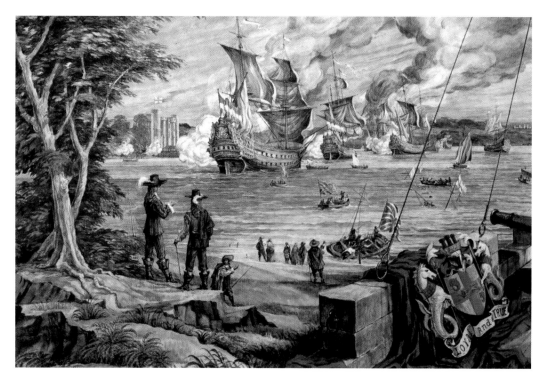

Smash and Grab
The Dutch fleet's raid on the River Medway in 1667. Under the command of Admiral de Ruyter, the Dutch sank sixteen British ships, which were refloated and taken to Holland. Upnor Castle, completed in 1571, was pitifully under-equipped with just four working guns and unable to offer any defence against the invaders.

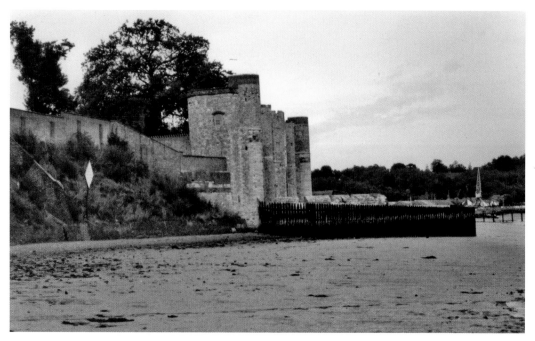

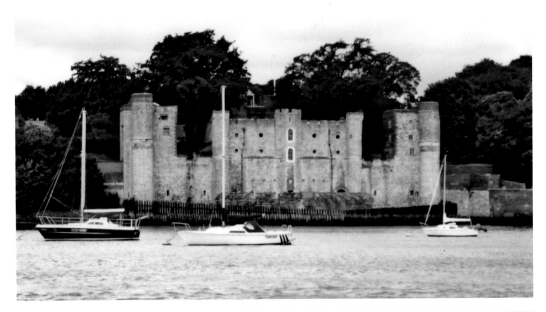

Restored Pride

After its failure against the Dutch, Upnor Castle supplied gunpowder and munitions to British warships. Extensively restored over the years, it is now open to the public each summer and hosts weddings and other functions.

Welcome to
Upnor Castle

This Tudor artillery fortress, built in 1559 to protect the new Chatham Dockyard and fleet anchorage, saw action during the famous Dutch raid of 1667, before undergoing conversion into a huge gunpowder magazine.

Opening Times

1 April – 31 October Daily: 10am – 6pm (October 4pm)
1 November – 31 March: Closed

Last admission is 45 minutes before closing

Medway
Serving You

Property managed by Medway Council
Tel: 01634 718742 / 843666

⚠️

For your safety

Please take care as ancient monuments can be hazardous. Children should be kept under close control.

Wilful damage to the monument is an offence. Unauthorised use of metal detectors is prohibited.

Customer services tel: 0870 333 1181
www.english-heritage.org.uk

ENGLISH HERITAGE

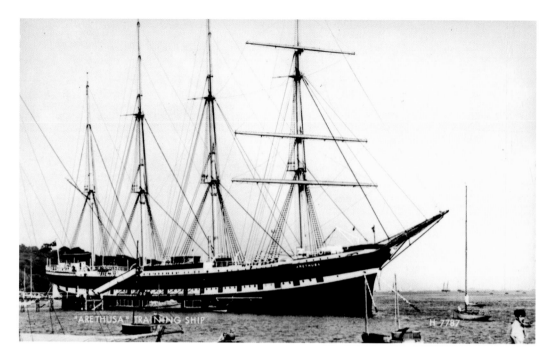

Graceful Times

For more than four decades shipping calling at Chatham, Rochester and beyond would pass one of the most well-known sights on the Medway – the training ship *Arethusa*, moored off Lower Upnor. Built as *Peking*, a four-masted barque sailing worldwide for the German-owned Laeisz Line, she was acquired by Shaftesbury Homes and fitted out to accommodate up to 240 boys wishing to pursue careers at sea. In 1975 she left the Medway for New York where to this day she displays her original name, *Peking*. The reach where she lay is now a busy mooring for small craft.

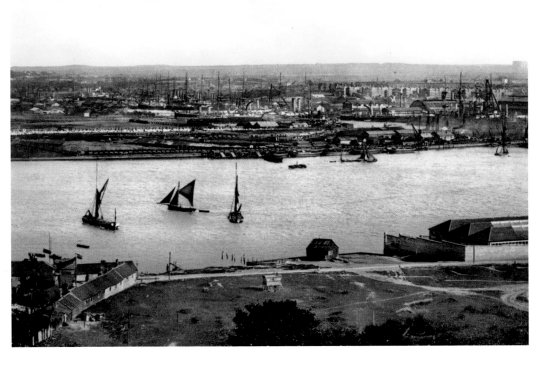

Basin Full
Chatham Dockyard, viewed from Upnor in the early 1900s. The No. 1 repairing basin can clearly be seen to the right. Since the closure of the dockyard this basin has been transformed into a 300-berth marina.

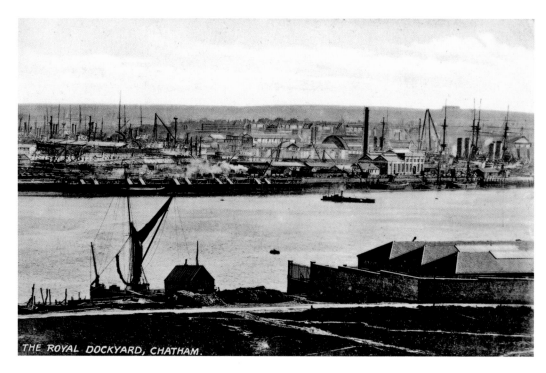

THE ROYAL DOCKYARD, CHATHAM.

Ancient and Modern

Another view of Chatham Dockyard, around the end of the nineteenth century. Note the forest of masts and funnels in the crowded dockyard basins to the left and two large vessels drydocked on the right. A spritsail barge enjoys a more tranquil environment in the foreground. Today there is a mix of old and new: the red-bricked Pump House No. 5 is an official ancient monument, while a pair of ultra-modern apartment blocks look down upon proceedings.

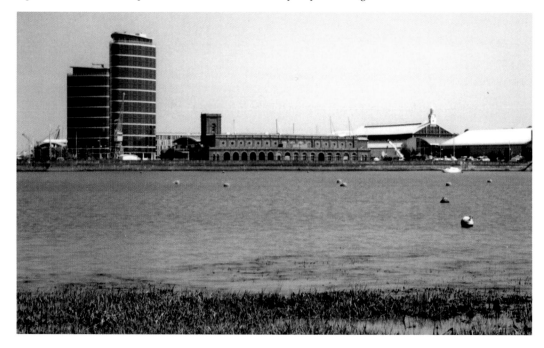

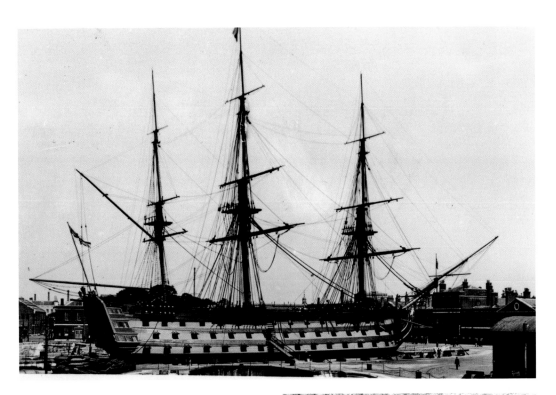

Her Fame Lives On

Laid down in the old Single Dock (now No. 2 Dry Dock) on 23 July 1759, Chatham's most celebrated ship, HMS *Victory*, was launched in May 1765. After fulfilling man-of-war duties she returned to the Medway as a hospital ship, tending sick and wounded French and Dutch prisoners. Horatio Nelson found her lying in a sad state and requested the Admiralty to recondition her as his flagship. The rest, as they say, is history although she later reverted to a hulk for many years before being rescued in 1922 and has been on display at Portsmouth ever since. A small plaque in front of No. 2 Dry Dock denotes her place of birth.

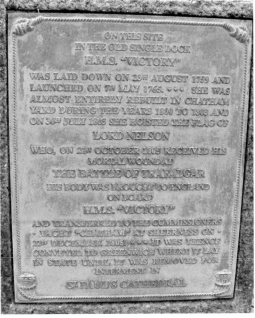

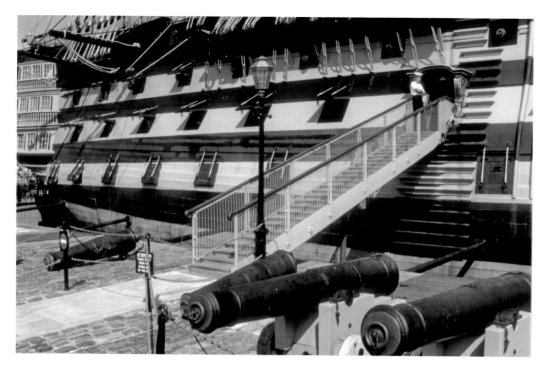

Wooden Walls

The sturdy, high-sided structure of wooden built men-of-war such as HMS *Victory* was aptly referred to as the 'wooden walls'. An exhibition under that name in Chatham Historic Dockyard demonstrates how these fighting ships were constructed of oak, beech and fir, while several replica ships, such as the *Grand Turk*, a copy of an eighteenth-century frigate, have visited Chatham in recent years.

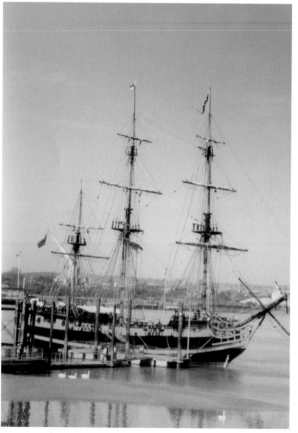

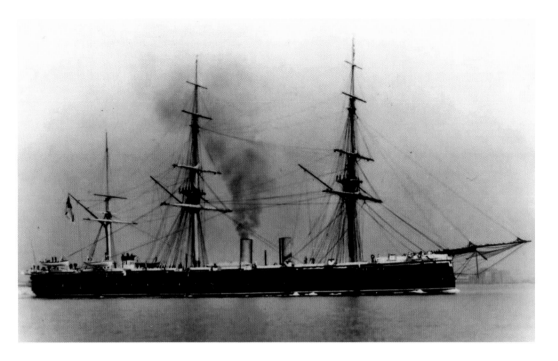

Chatham's Biggest

Launched on 23 December 1863, HMS *Achilles* was the first iron ship built at Chatham and, at the time, the biggest ship in the world. With a displacement of 9,820 tons and 124.5 m long, she was equipped with a 12.5 ton screw propeller and 50,000 sq feet of canvas. In 1900 the dockyard's No. 8 Slip was completed specifically for the construction of battleships, but only one, HMS *Africa*, was actually built there. Launched on 20 May 1905, she displaced 16,350 tons and measured 139.5m in length, making her the biggest ship ever built at Chatham.

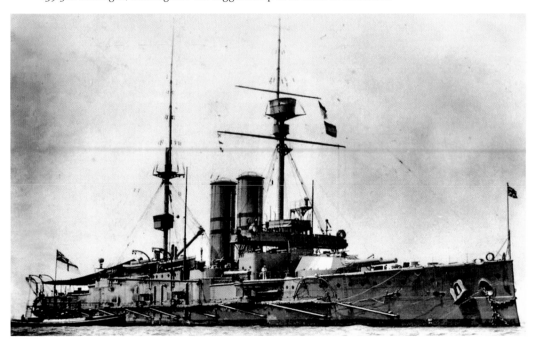

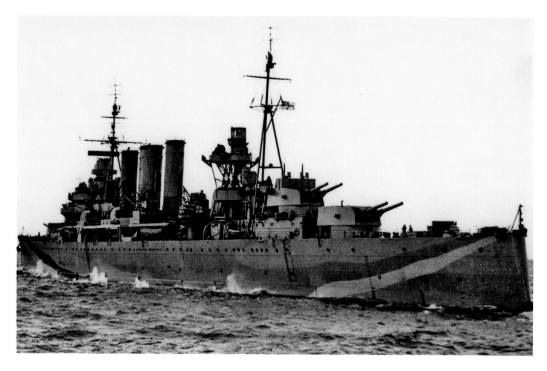

Home County

Eleven ships have been launched as HMS *Kent* over the past centuries, the ninth of which was laid down at Chatham in November 1924. A County-class cruiser, she had a standard displacement of 10,570 tons and gave valuable national service until she was broken up in 1948. The current HMS *Kent*, a Type-23 frigate, creates a contrasting sight on a recent visit to her home county.

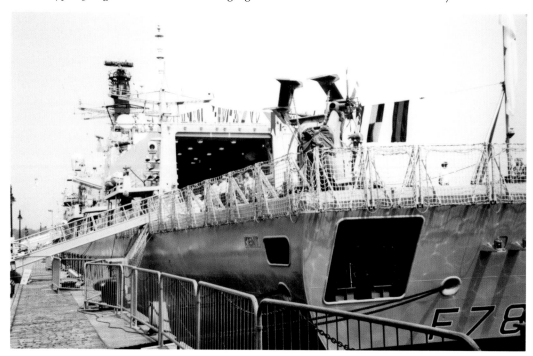

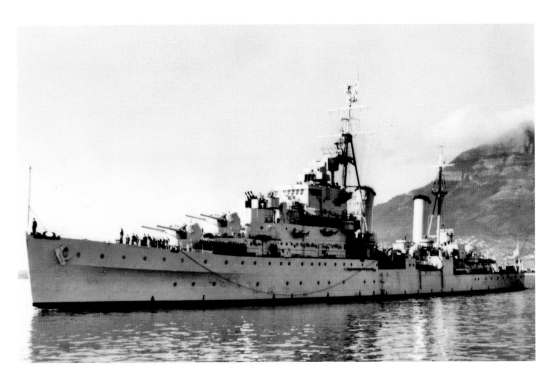

Slipping Into the Past

The last cruiser built at Chatham, HMS *Euryalus*, 5,450 tons displacement, was launched from No. 8 Slip on 6 June 1939. After 1944 the slip ceased to be used and has been consigned to history with the building of the Medway Tunnel and nearby Dockside Outlet Centre (pictured).

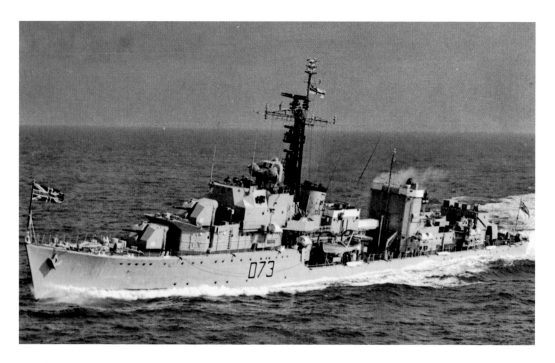

Cavalier Lives On

Making speedy progress during her distinguished career, the 1944-built destroyer HMS *Cavalier* was awarded the 'Arctic 1945' Battle Honour and sailed the world's oceans until 1972 when she paid off at Chatham. Following years of lay-up at various locations she was purchased by a preservation trust and in May 1999 she arrived back at Chatham, where she is now open to the public in No. 2 Dry Dock in the Historic Dockyard.

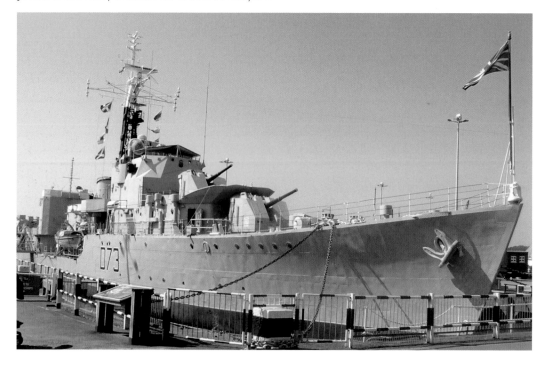

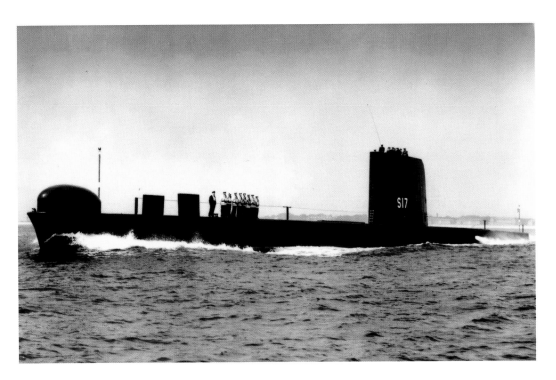

Return of the *Ocelot*

The fifty-fourth of fifty-seven submarines built at Chatham Dockyard and the last produced by the yard for the Royal Navy, HMS *Ocelot* was launched on 5 May 1962 and undertook five commissions for the 1st and 3rd Submarine Squadrons, patrolling predominately in European waters. Retiring from service in 1981, she was saved from the breakers by the Chatham Historic Dockyard Trust, who brought her back to her birthplace where she was initially moored against the river wall.

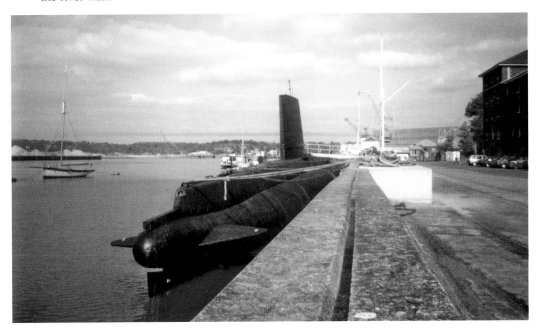

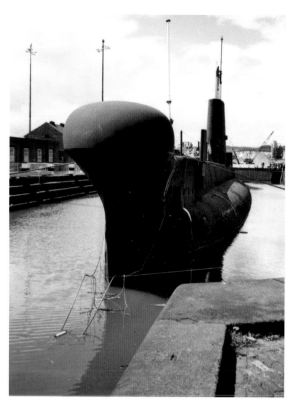

High and Dry
Her bulbous prow resembling a giant serpent's head, HMS *Ocelot* makes herself at home in No. 3 Dry Dock. Soon the waters are pumped out and the submarine settles into her new life as a public attraction next door to HMS *Cavalier*.

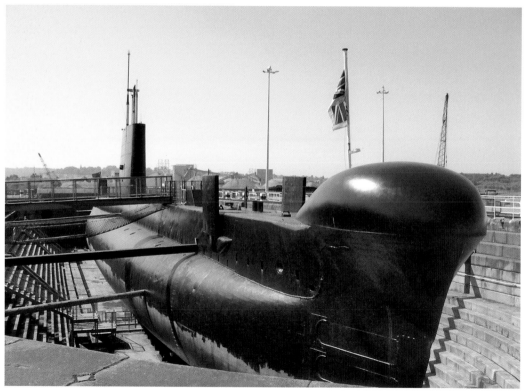

Perfectly Restored

By far the oldest of the three-ship exhibition at Chatham Historic Dockyard, HMS *Gannet*, a Dotterel-class screw sloop, was launched at Sheerness Dockyard in August 1878. In 1904 she became HMS *President*, moored on the River Thames in London, before being fitted out as HMS *Mercury*, a training school based on the River Hamble. When restoration work at Chatham began only her hull and foremast were in evidence, but today she appears as she was built all those years ago.

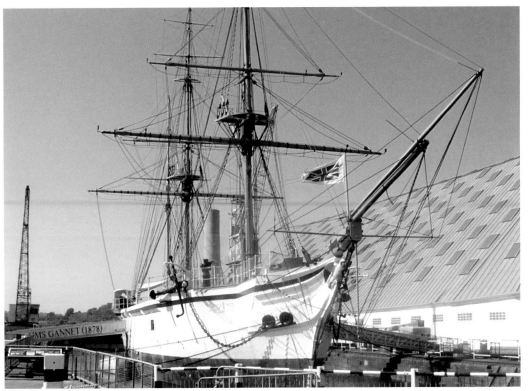

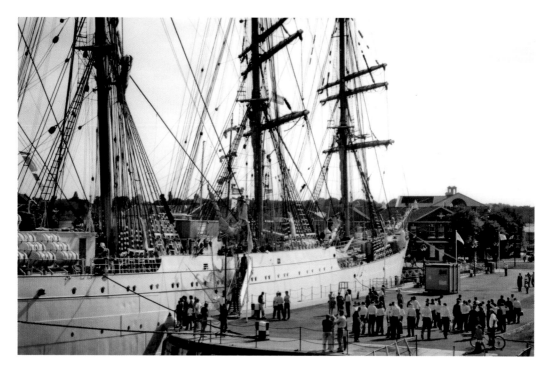

The Navy's In
The crew of a tall ship gather on the quayside of No. 2 Basin, now part of Chatham Maritime. Chatham Navy Days, a hugely popular event that ran from 1928 to 1981 (with a wartime break), was briefly revived in 1999 for three years, attracting ships of various nationalities, including the Irish coastal patrol ship *L. E. Ciara*.

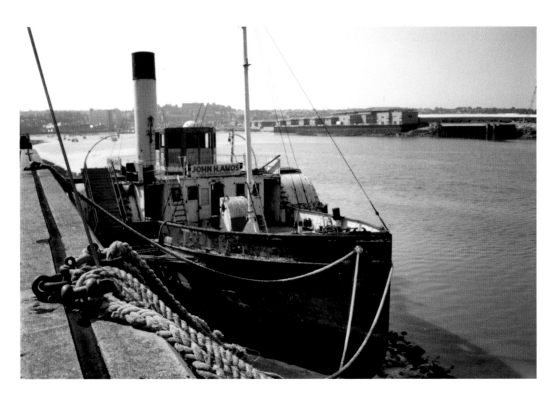

Restoring Faith

Owned by the Medway Maritime Trust since 2001, the paddlewheel tug *John H. Amos* was built for River Tees service in 1931 but has been based in north Kent since 1976. One of only two British-built paddlewheel tugs still in existence, her condition has deteriorated while at Chatham (below) but her owners maintain faith in acquiring funds for her restoration.

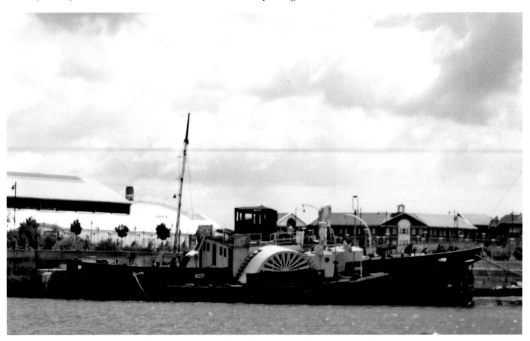

Dockyard Work

The covered slips of the former Chatham Naval Base. On the far left is No. 7 Slip, birthplace of Chatham-built submarines. Before the completion of the three-ship exhibition in the Historic Dockyard, one of the huge dry docks awaits the arrival of a ship for repair.

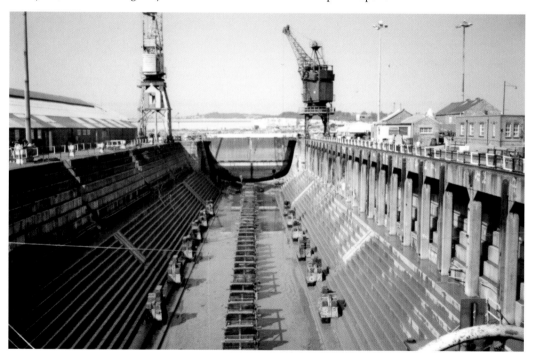

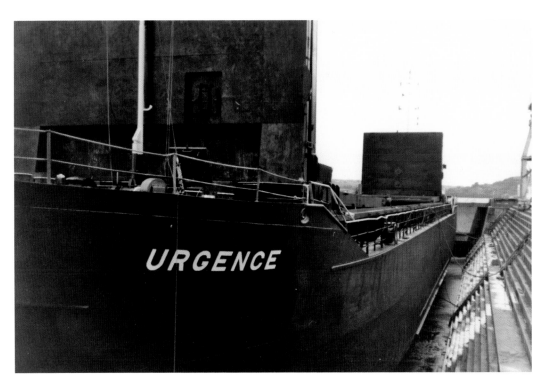

Work Underway
Crescent Shipping's coaster *Urgence*, 1981/699grt, and, a few years later, a bright-red lightship, being overhauled in the dry dock now occupied by HMS *Gannet*.

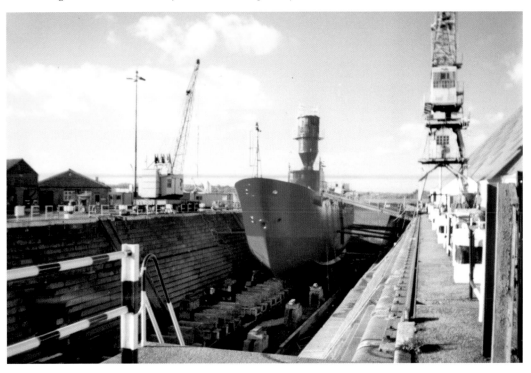

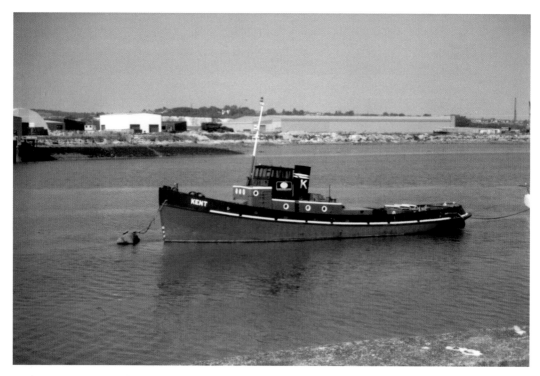

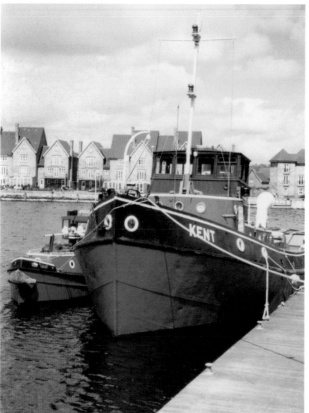

Tug's New Life

Built in 1948 for J. P. Knight Ltd, the 121grt tug *Kent* was laid up following retirement in 1983 until purchased by the South East Tug Society for the princely sum of £1. Now restored to pristine condition, her home is the marina basin at Chatham Maritime.

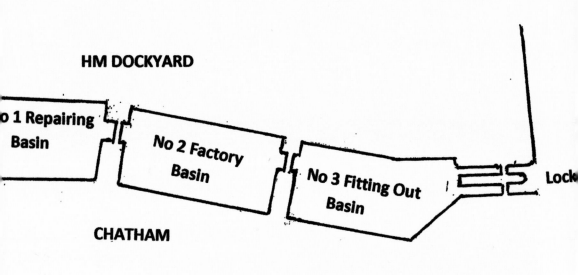

HM DOCKYARD

No 1 Repairing Basin

No 2 Factory Basin

No 3 Fitting Out Basin

Lock

CHATHAM

A Variety of Trades
The three basins of Chatham Dockyard covered in total over 68 acres of enclosed water. Basin 3 – the Fitting Out basin – was redeveloped into a commercial enterprise after the dockyard closed. Known as Chatham Docks, it handles aggregates and sand, ferrous exports, steel coil, scrap metal and newsprint and forest products.

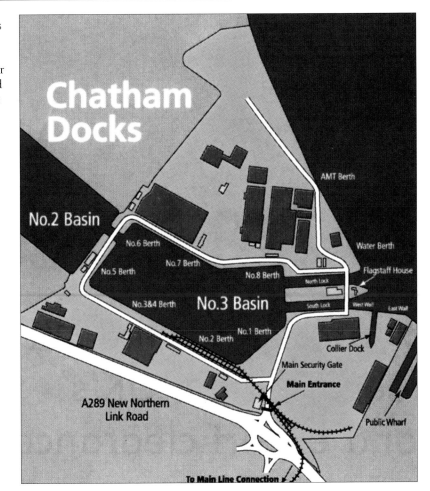

Chatham Docks

No.2 Basin

No.6 Berth

No.7 Berth

No.5 Berth

No.3&4 Berth

No.2 Berth

No.1 Berth

No.8 Berth

No.3 Basin

AMT Berth

Water Berth

Flagstaff House

North Lock

South Lock

West Wall East Wall

Collier Dock

Main Security Gate

Main Entrance

Public Wharf

A289 New Northern Link Road

To Main Line Connection

Chatham Callers

The 1,521grt *Union Pluto*, built in 1985, makes her way up the Medway to Chatham Docks. With the demise of upriver industries, Union vessels ceased to venture beyond Rochester Bridge. At No. 6 berth one of the largest ships to use Chatham docks, the Swedish ro-ro vessel *Baltic Bright*, 1996/9,708grt, unloads via her stern ramp.

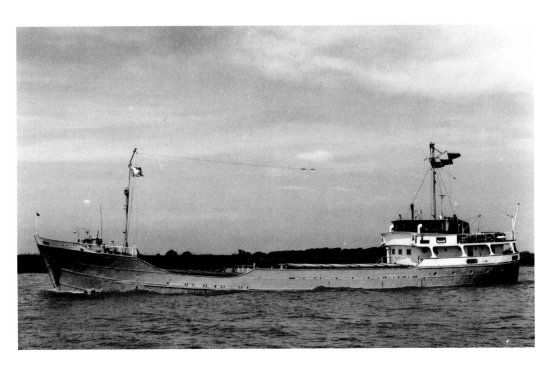

The Hoo ships

On the banks of the Medway at Hoo the Lapthorn family created one of the UK's largest fleets of coastal cargo ships. In 1970 they purchased the 1955-built Dutch vessel *Ida-D*, 494grt, renaming her *Hoocrest*. As the fleet was modernised a second *Hoocrest*, at 794grt, entered service in 1986. This vessel was transferred to Coastal Shipping in 2006 and renamed *Curlew*, but more recently has become *River Carrier* for Riverline Trading.

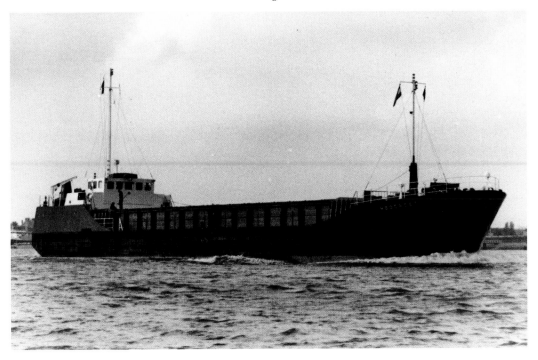

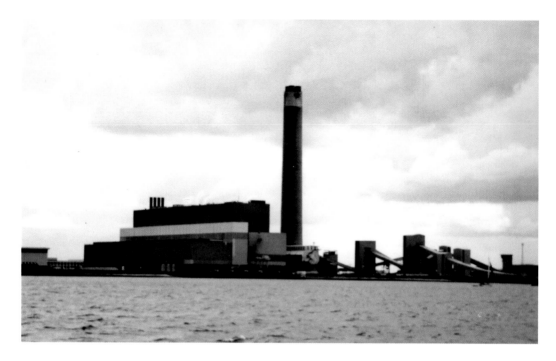

Early Closing

Built between 1963 and 1973 by the Central Electricity Generating Board, Kingsnorth Power Station, with its distinctive tall chimney, soon became a prominent landmark on the Hoo Peninsula. Ownership passed to EON.UK who made the shock announcement in March 2012 that, due to EU legislation, power generation would cease in March 2013. Demolition will be complete by 2016, by which time the bulkers *Malmnes*, 1993/5,883grt, and EON-owned *Lord Hinton*, 1986/14,201grt, will hopefully have found further employment.

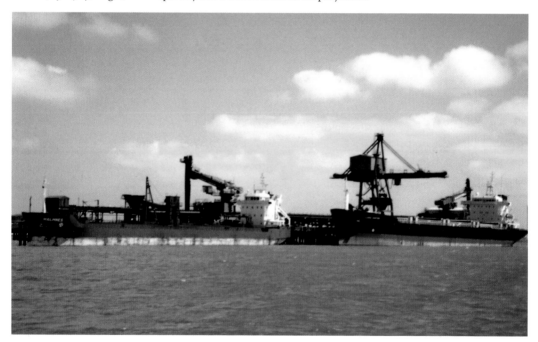

'Brickies' Remembered

While taking a break from her summer jaunts to Rochester and other locations, the Thames barge *Edith May* rests in the old brickmaker's dock at Lower Halstow as a tea room. In the early 1900s Lower Halstow Creek would be inundated with 'brickie' barges, loading supplies from Eastwood's brickfield for London. In the twenty-first century the creek paints a peaceful picture of small privately-owned boats.

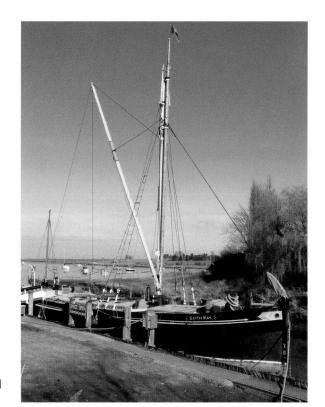

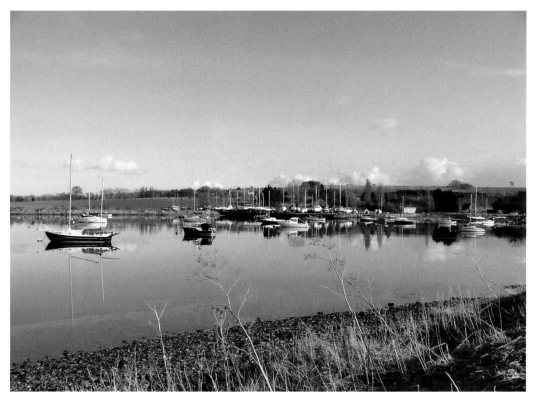

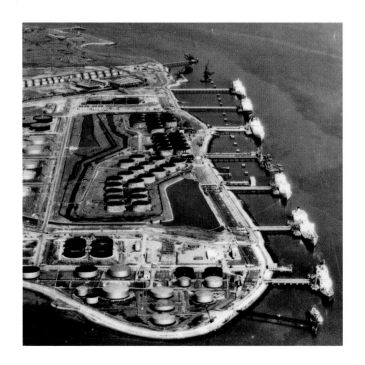

Terminal Changes

The BP refinery on the Isle of Grain during its prime years. Following its closure Thamesport container terminal was constructed on its site and the surrounding marshland. In the 2008 view of the terminal below, Grain power station can clearly be seen near the top, immediately above the location of a new Liquid Natural Gas terminal yet to be constructed. Towards the bottom is No. 1 Jetty, currently operated by BP who retain a limited presence at Grain. (Top picture copyright BP)

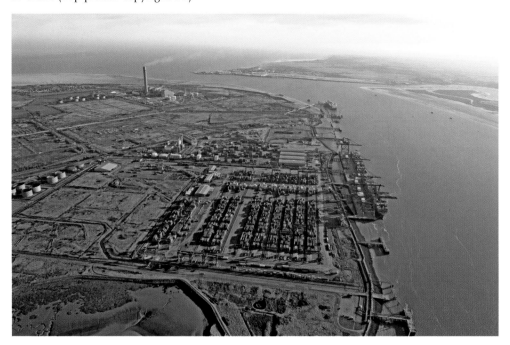

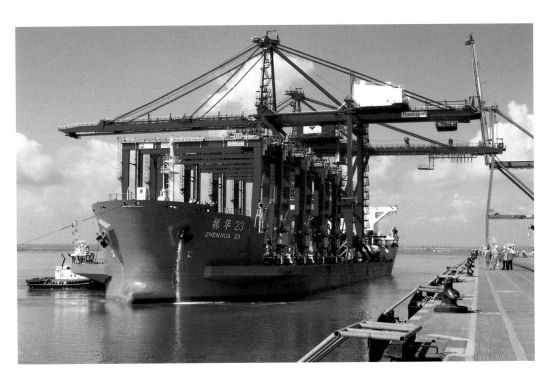

Special Delivery

As Thamesport continued to grow, eight gantries and a container-handling crane (the second crane was bound for Felixstowe) were delivered to the terminal in 2008. There are now eight cranes in operation, one extending the width of twenty-two 20-foot equivalent units (TEU), one twenty-one TEU wide, one eighteen wide and five seventeen wide.

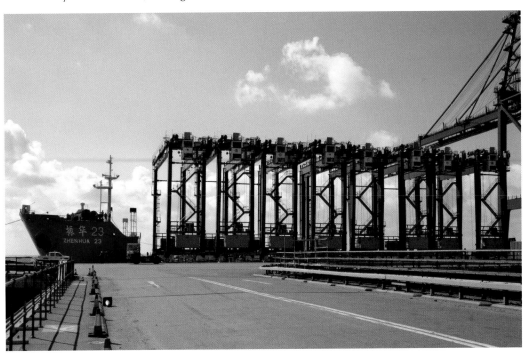

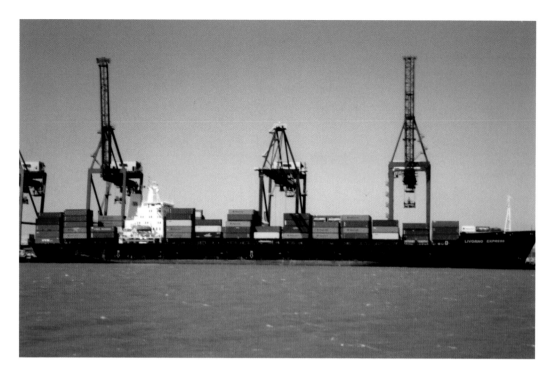

Room For More

Hapag-Lloyd's 37,474grt *Livorno Express* loads at Thamesport. With room for 2,846 TEU, she would have been regarded as one of the more capacious container ships on her completion in 1991. In recent years, however, a new generation of giant ships with more than twice her capacity have taken to the waves. Thamesport handles vessels of up to 94,000 gross tons, including *Anna Maersk*, 2003/93,480grt.

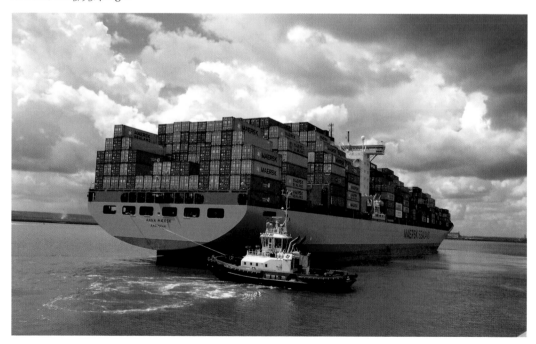

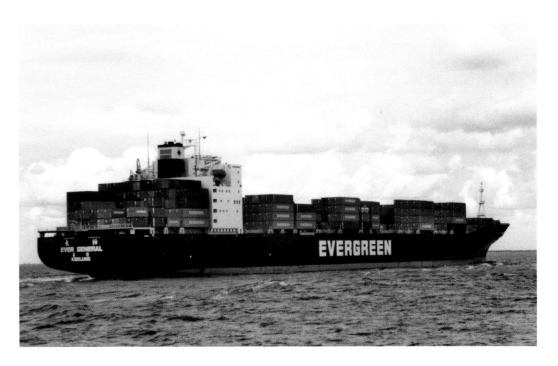

Evergreens Keep Growing

Since 1991 the huge Taiwan-based Evergreen organisation has featured Thamesport as a regular UK port of call on its worldwide container ship routes. An early example of its ever-growing fleet was *Ever General*, 1987/46,410grt, which could transport up to 3,400 TEU. Joint services are offered by some container ship companies using Thamesport, but Evergreen operates a stand-alone service, a recent addition being the considerably larger 8,084 TEU *Ever Chivalry*, 2006/90,449grt.

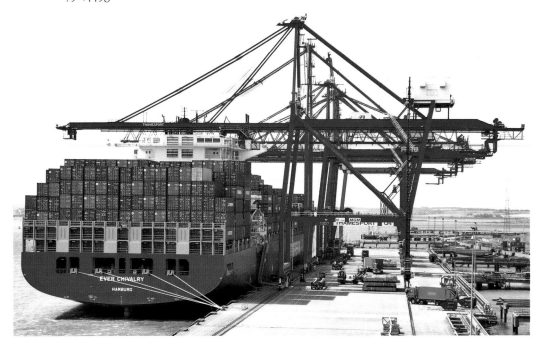

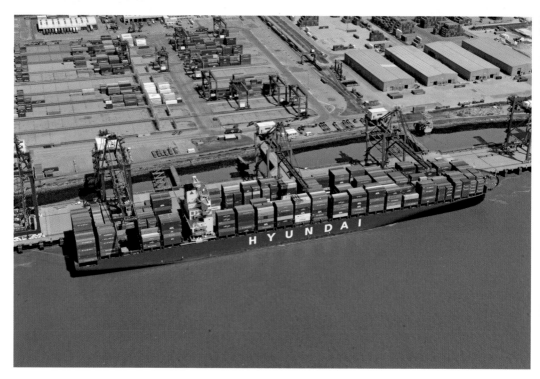

Asian Visitors
Container ships of the South Korean conglomerate Hyundai offer a weekly service out of Thamesport. Among the largest vessels using the terminal, their giant blue hulls dominate the quaysides.

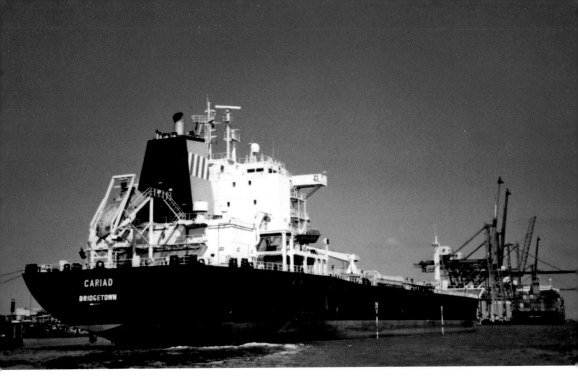

Shapes and Sizes

Although the BP refinery closed almost thirty years ago, the BP Company retains a limited presence on the Isle of Grain, bringing in aircraft fuel. This is delivered to the old No. 1 Jetty, where the 28,337grt *Cariad* was berthed in 2010. Compare the design of this 1996-built ship with that of the little *British Loyalty*, 1949/8,592grt, whose bridge superstructure was positioned amidships.

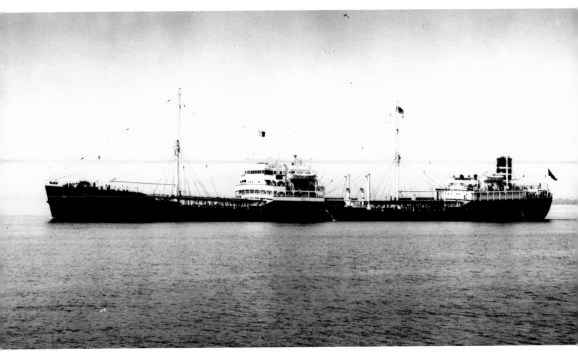

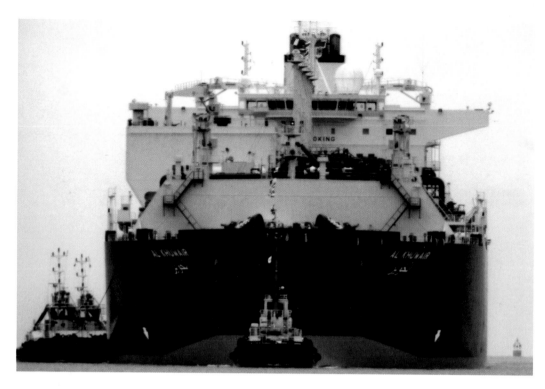

Medway's Biggest

Assisted by local tugs, the largest ever ship to sail into the Medway arrived at National Grid's Isle of Grain terminal on 17 November 2008 with a delivery of 50 million therms of liquefied natural gas. The newly-completed 135,848grt LNG tanker *Al Khuwair*, under charter to Centrica, measures 315 m by 50 m. The facility uses Jetties 8 and 10 of the former BP refinery and incorporates three LNG storage tanks, each the size of the Royal Albert Hall. The sheer scale of the giant *Q-Flex* tanker is a far cry from BP's own tankers of the 1950s, such as *British Splendour* of just 11,233grt, which would call at the Grain refinery. (Top photograph copyright *Medway Messenger*)

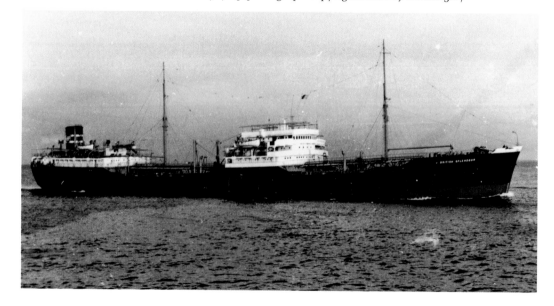

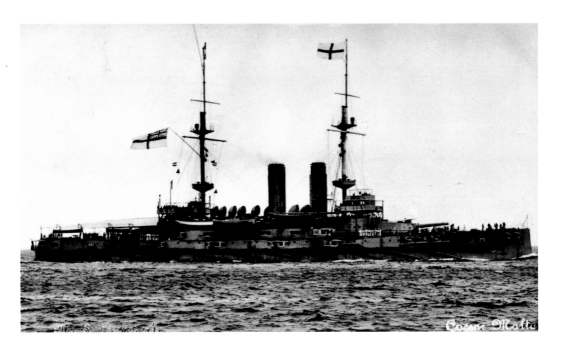

Medway Tragedy

On the morning of 26 November 1914 the 15,000 ton battleship HMS *Bulwark*, built in 1899, was anchored at buoy number 17 at Kethole Reach accompanied by other ships of the Fifth Battle Fleet. Suddenly, without warning, there was a huge explosion and within one minute *Bulwark* had disappeared, blown completely apart and taking more than 700 officers and men with her. A plaque can be found at Sheerness, next to the town's war memorial, both of which commemorate those who were lost in this terrible tragedy, the exact cause of which has never been established.

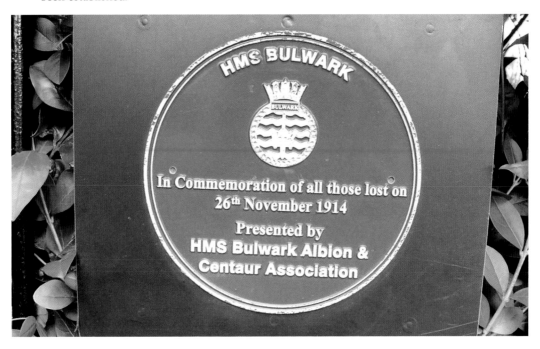

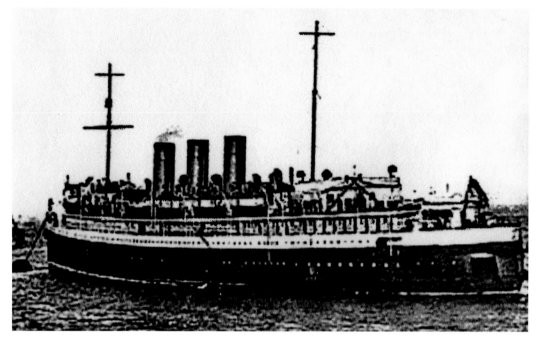

A Second Disaster

Just a mile downriver from the wrecked HMS *Bulwark*, the Medway observed a similar disaster on the morning of 27 May 1915. The 5,394grt *Princess Irene*, built in 1914 for Canadian Pacific and converted into a wartime minelayer, was anchored in Salt Pan Reach, just off Port Victoria Pier, when she exploded. 352 lives were lost, including seventy-six dockyard workers. The Sheerness war memorial remembers also those who died in this, the Medway's second First World War tragedy.

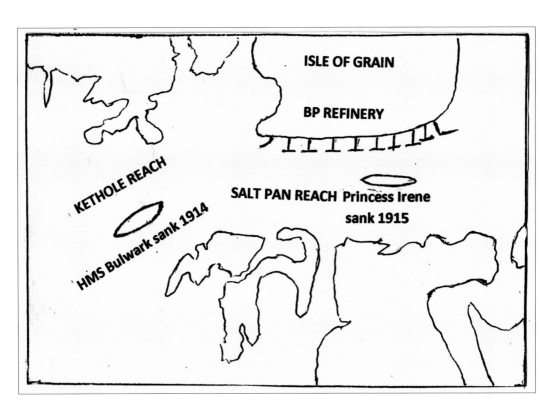

Past and Present
The lower Medway has witnessed maritime disasters and the creation of new ports.

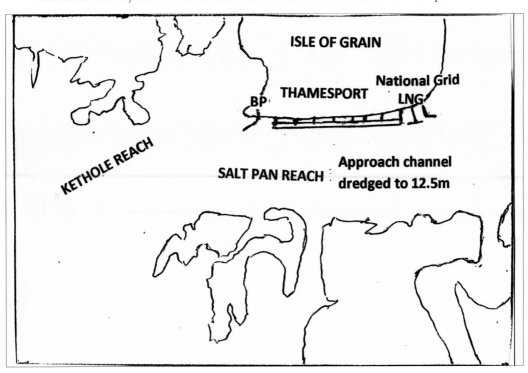

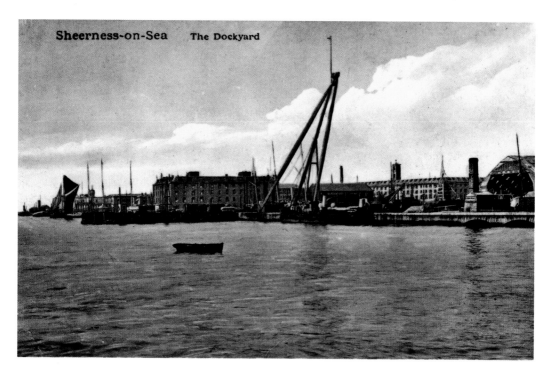

Sheerness-on-Sea The Dockyard

All Change at Sheerness

Viewed from the old pier, Sheerness Dockyard around a century ago. A ship is under repair while large storehouses dominate the background. Today, commercial shipping is handled on the busy quaysides.

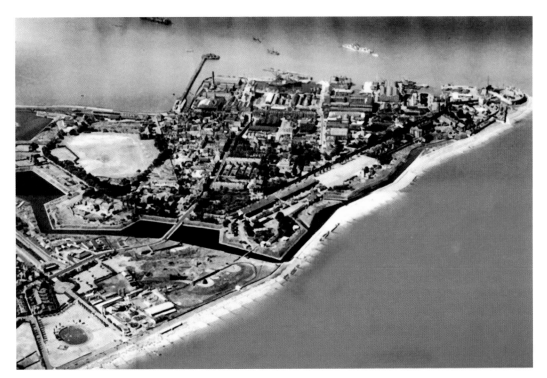

A New Port

Sheerness and its dockyard as it appeared before the yard's closure in 1960. To the far right is Garrison Point, where the Medway enters the Thames estuary. In just one day the dockyard site was sold as a commercial enterprise to become Sheerness Docks, handling refrigerated produce, forest products and vehicles. In 1997 Lappell Bank, to the south, was reclaimed to provide storage for up to 45,000 cars.

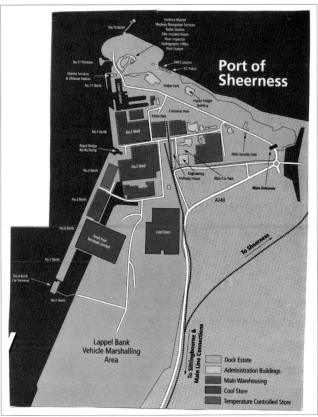

Fighting Ships to Fruit

A destroyer under repair in Sheerness Dockyard when the yard was a hive of activity. A hundred years on, the refrigerated cargo ship *Spring Dragon*, 1984/12,783grt, discharges fresh produce at a Sheerness Docks terminal.

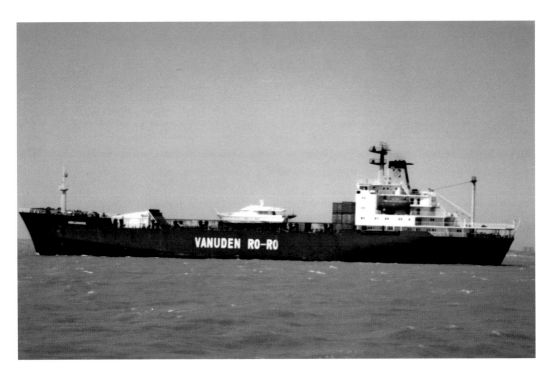

Final Salute

The Panamanian-registered ro-ro vessel *Maximahaven*, 8,548grt, included Sheerness in her European and Mediterranean itinerary. Built in 1979 for the former USSR, she was operated by Van Uden Ro-Ro of the Netherlands. In 2009 she made her final visit to the Medway, receiving a grand farewell salute from Sheerness tugs, before sailing to Turkey and the breaker's yard.

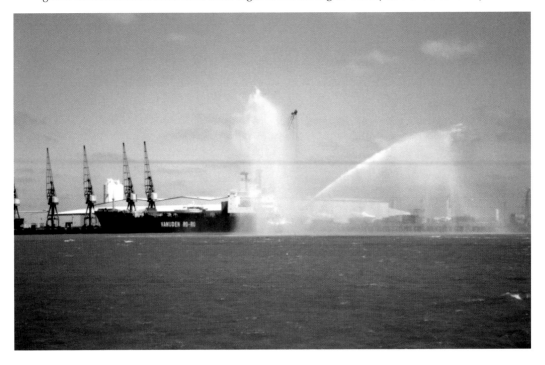

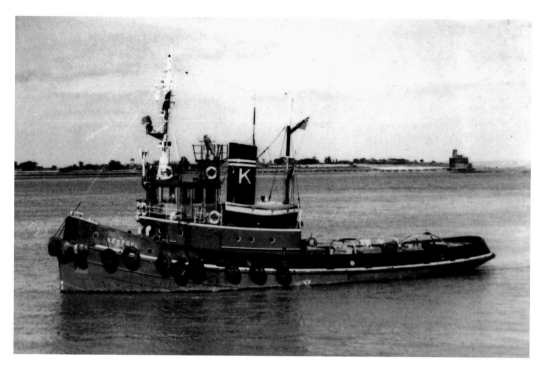

Big-ship Towage

Designed to handle ocean tankers at the Isle of Grain refinery, Knight's 223grt *Kestrel* was completed in 1955. By the turn of the century Medway towage was in the hands of the large Australian concern Adsteam, whose tug *Lady Maria*, 1975/247grt, was employed at Sheerness and Thamesport.

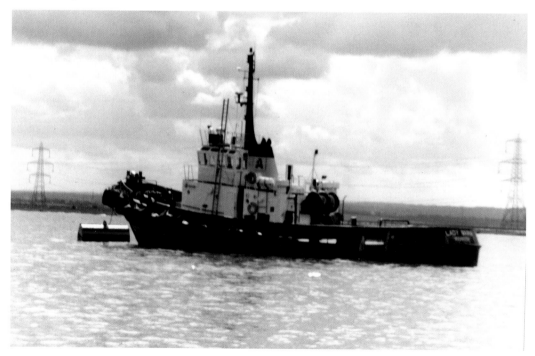

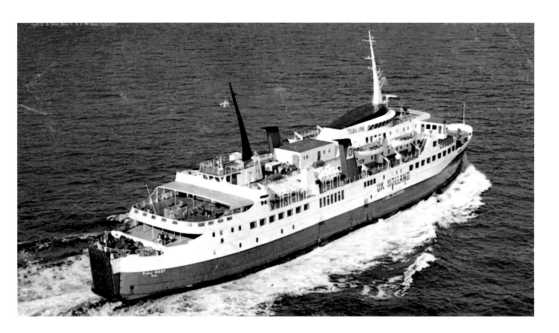

Olau Moves In

In 1975 Olau Line opened a passenger/car ferry service between Sheerness and Vlissingen (Flushing) with the sisters *Olau West* and *Olau East*. But they soon proved too small to meet growing demand. *Olau East* moved on within a year, while in 1977 *Olau West* became *Corsica Marina* for Corsica Ferries, for whom she served for fourteen years. Seeking larger tonnage, Olau chartered *Finnpartner* from Finnlines, renaming her *Olau Finn*. The 7,889grt vessel had started life in 1966 as *Saga* for Swedish Lloyd and ran alongside another acquisition, *Olau Kent*, on the Sheerness route for the next four years.

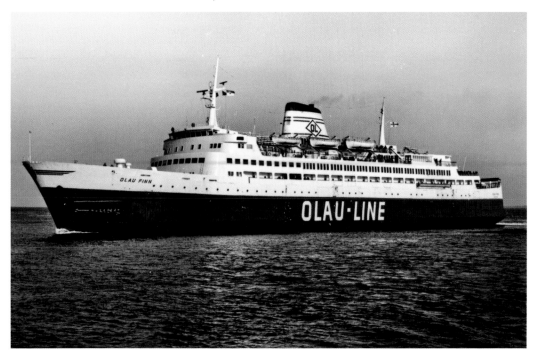

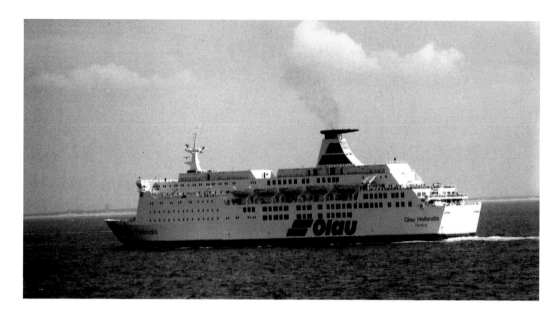

From Expansion to Closure

By 1980 Olau had been acquired by German-based T-T Line, who ordered a pair of much larger ferries for the Sheerness-Vlissingen route. The 14,990grt *Olau Hollandia* (above) and *Olau Britannia* entered service in 1981 but at the end of the decade they were replaced by two 33,336grt sisters of the same names as demand for passenger and vehicle capacity continued to increase. The first *Hollandia* now operates in the Baltic as *Nordlandia*, while her sister has led a varied career, recently sailing from Swansea to Cork as the *Julia*. The newer pair set a high standard of comfort, but in 1994 action by the German Seamen's Union against re-flagging the ships outside Germany forced the Olau service to close down. Both ships were chartered to P&O Ferries until 2005, when they were sold to SNAV for service between Italy and Sardinia.

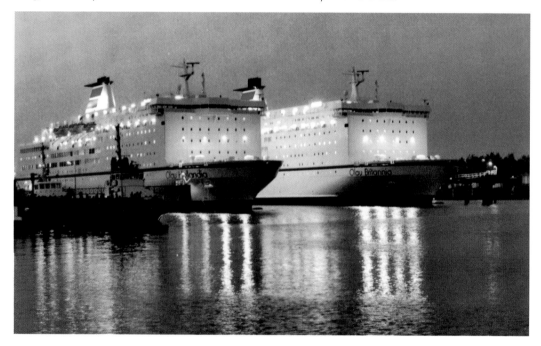

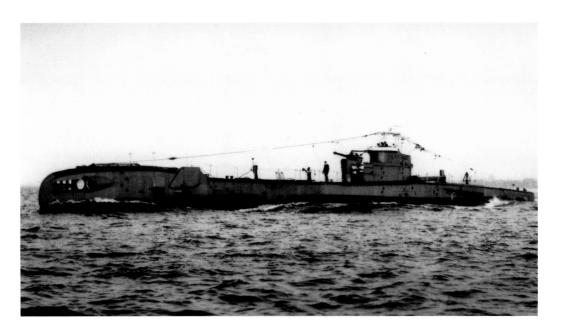

A Tragic Misjudgement

A third tragedy that shook the Medway community took a further fifty-seven lives. Barrow-built HMS *Truculent* was a 'T'-Class submarine similar to HMS *Turpin* (above), which was built at Chatham in 1944. On 12 January 1950 *Truculent* left the River Medway for sea trials, carrying several Chatham Dockyard workers in addition to her normal crew. That evening, in the Thames Estuary, she collided with an outward-bound Swedish cargo ship, the *Divina*, which her commander had misjudged as being stationary, and sank into the muddy waters. She was raised two months later, by which time a disaster fund had been set up in the Medway Towns.

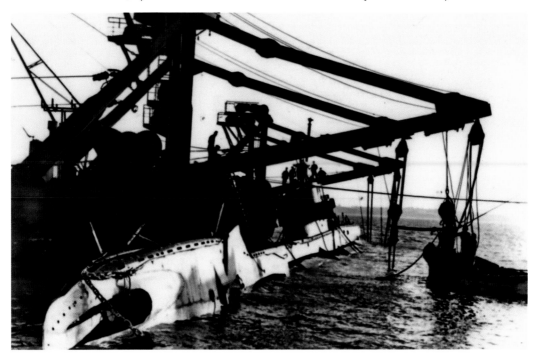

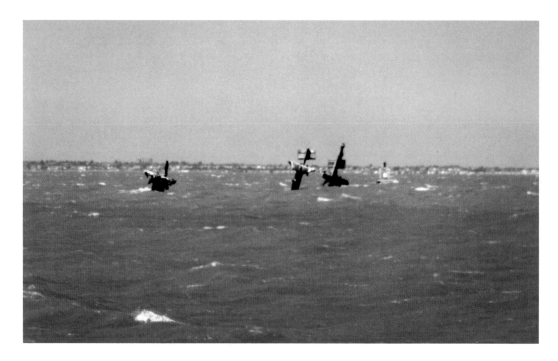

Liberty Ships' Reunion

The wreck of the 7,176grt American Liberty ship *Richard Montgomery* lies in the Thames Estuary off Sheerness where she broke up and sank in August 1944. One of 2,710 Liberty ships mass-produced during the Second World War, she was en route from Philadelphia to Cherbourg carrying munitions for the US Air Force. Salvage work was never completed and consequently she still holds at least 1,200 tons of explosives. In 1994 the last operational Liberty ship, the restored *Jeremiah O'Brien*, visited Britain to mark the fiftieth anniversary of the D-Day landings and passed her stricken sister on her way to Chatham.

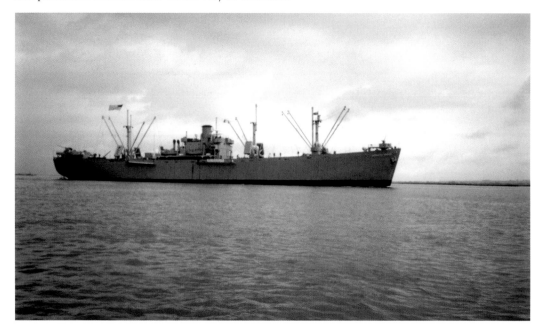

CHAPTER THREE

The Swale

The Kentish Swale (as distinguished from Yorkshire's River Swale) runs south-eastwards and then eastwards, between the little port of Queenborough on the Isle of Sheppey and Whitstable. Like the lower Medway, shallow creeks feed into its waters, and these were ideal for the sailing barges that would serve the local cement and brickmaking factories. The area boasted an abundance of brick earth for the brickfields and chalk, mud and clay for cement manufacturing, most of which was transported by barge. These flat-bottomed vessels would sit on the creeks' mud at low tide while loading and so many were needed that it was inevitable that barge-building would soon grow as another important local industry.

The western section of the Swale is crossed by two busy road bridges and is considerably narrower than its easterly waters, but where it widens, Ridham Dock was completed in 1917 to handle ships bringing in pulp for paper making. At the head of nearby Milton Creek at Sittingbourne, Kemsley Mill was built in 1925 for the production of newsprint and is currently flourishing under the ownership of D. S. Smith Plc. Milton Creek itself was especially prominent for the handling of barge traffic from the early nineteenth century onwards and also for barge-building, with the construction of more than 400 spritsail rigged sailing barges. The brickmaking firm Eastwoods took over a yard here for building their own barges, while downstream at Conyer, a backwater in Teynham that by the late 1800s was fairly bustling with barges, the company acquired its own wharf and, in 1919, the cement mills.

Situated further downstream, Faversham has been a busy north Kent port for many centuries, its creek handling predominately deep-water vessels before the arrival of the Victorian sailing barge. The shipyard of James Pollock & Co. Ltd specialised in the construction of small coasters and motor barges until closing in 1970. Some eight kilometres to the east, adjacent to the Swale's outlet into the Thames estuary and then the North Sea, lies the attractive coastal town of Whitstable. Renowned for its oysters, the resort has numerous restaurants serving freshly-caught shellfish. Oyster production once reached four million per year, but severe winters and pollution contributed to the decimation of stocks around the middle of the last century. However, business is flourishing again and fishing boats, although not in the numbers of old, are still a feature of Whitstable Harbour.

Whitstable Harbour was built by the Canterbury & Whitstable Railway Company and opened in 1832. It gave shelter for up to twenty sailing ships and provided a dock for transferring cargoes from sea-going to river vessels and sidings for eighty railway wagons. In 1948 the harbour came under the ownership of British Railways and as its facilities improved in the late 1950s, coastal vessels of Crescent Shipping became regular callers.

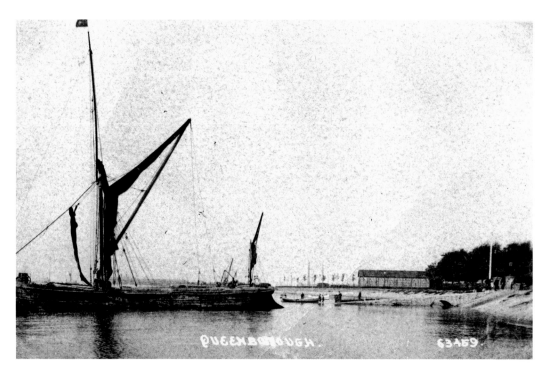

A Restful Harbour
A sailing barge heads gently out of Queenborough Harbour for the Swale. No barges were built at Queenborough but several were owned in the town during the early 1900s.

In recent years Whitstable's economy has relied not upon oysters, but a very different business – the 'blacktop' industry. Ever since the Kent Tarmacadam Company relocated to Whitstable Harbour in 1936, materials required for the making of road tarmac have become the principal cargoes handled at the harbour's quays. The third tarmac plant to be erected on East Quay was opened in 1985 and at twenty-five metres high is still Whitstable's tallest building.

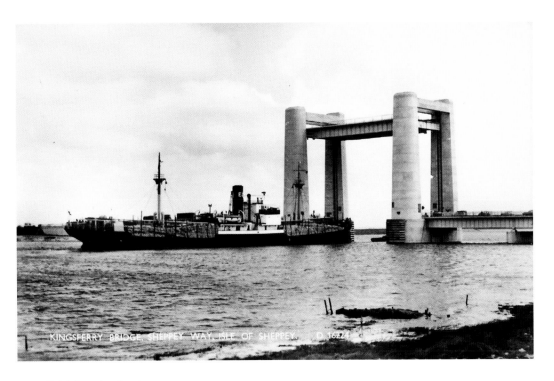

KINGSFERRY BRIDGE, SHEPPEY WAY, ISLE OF SHEPPEY. D 16224

Bridging the Swale

An elderly freighter passes through the Kingsferry Bridge, bound for Ridham Dock. The bridge was built in 1960 to carry road and rail traffic on to the Isle of Sheppey and is a vertical-lift bridge, meaning it has to be raised to its 27.5m height regularly. Consequently, as passing cargo ships became more modern, road traffic delays remained the norm. In 2006, however, the problem was alleviated with the opening of a larger road bridge.

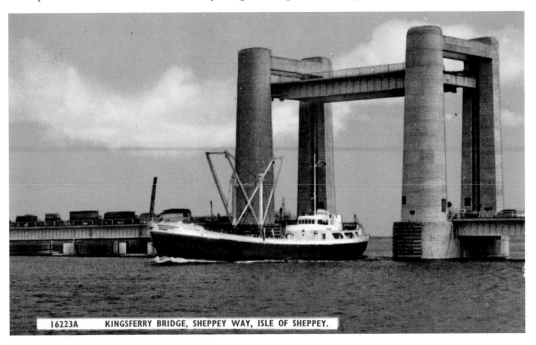

16223A KINGSFERRY BRIDGE, SHEPPEY WAY, ISLE OF SHEPPEY.

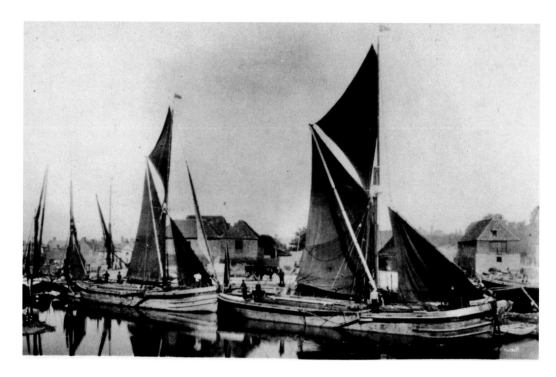

Bricks and Cement

The sailing barges *Water Lily* (left) and *Owner's Delight* moored in Milton Creek in 1880. The Sittingbourne creek was dominated by the cement and brick industries, even into the 1930s when Smeed Dean's own barges were busy discharging clay and loading bricks in Adelaide Dock. Sadly, as the businesses closed down, the old barge docks became derelict and gradually disappeared, while the creek has significantly silted up.

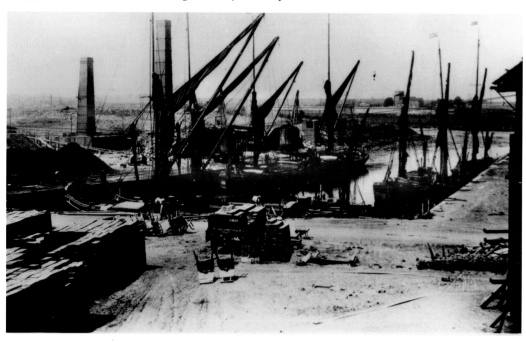

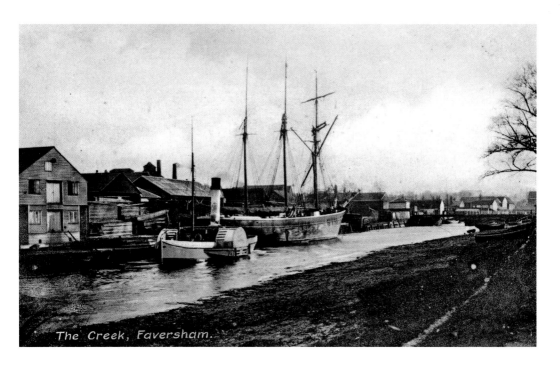

The Creek, Faversham.

A Thriving Creek

Faversham Creek pictured around the end of the nineteenth century. In those sailing ship days the residential paddle tug *Pioneer* towed vessels into Faversham. Even as late as the 1970s Faversham was still thriving, with seven working wharves, although no cargoes were brought in after 1989. Nowadays restored vessels tie up at Standard Quay while new homes enjoy views across the creek.

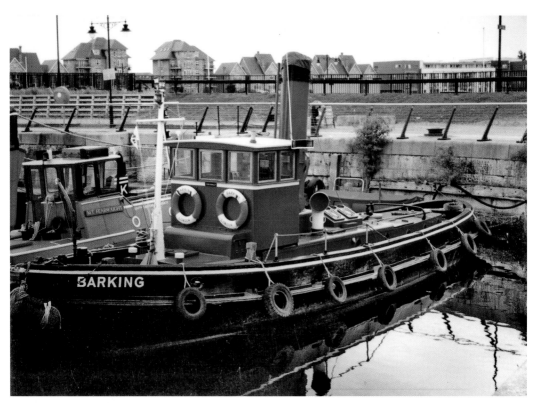

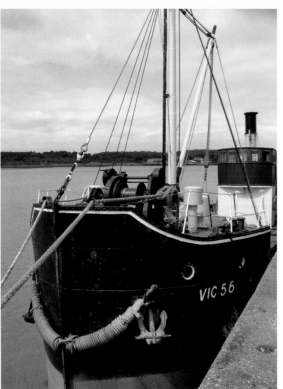

Made in Faversham

No fewer than 1,200 ships were built at the yard of J. Pollock & Sons Ltd in Faversham Creek between 1916 and 1969. Although more than forty years have passed since the yard's closure, two of its vessels have withstood the sands of time. Faithfully restored are the little tug *Barking*, which entered service in 1928 for the Gas, Light & Coke Company, and the 147-ton *VIC 56*, one of a pair of wartime Victualling Inshore Craft (or 'Puffers') built at the Faversham yard. Both ships are now based at Chatham.

Oysters and Hops

Behind a sailing barge moored in Faversham Creek stands Oyster Bay House, built at Iron Wharf in 1845 for use as a store for locally-picked hops awaiting shipping to London. Faversham has historic connections with the oyster business, the Faversham Oyster Fishing Company holding the accolade of being the world's first-ever company, established around 1190. The fishing connection is maintained today with the presence of a wooden-hulled trawler moored opposite modern housing.

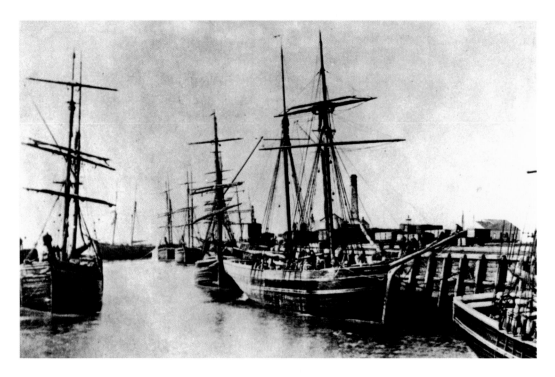

Masts at Whitstable

Sailing colliers discharge Northumberland coal in Whitstable Harbour around 1880. Some were Canadian-built and had sailed over to the UK. The coal was distributed by rail across south-east England. The Thames Sailing Barge *Greta* continues the tall-masted theme at Whitstable, from where she offers day trips in the summer months. Built in 1892 as a working cargo barge, she was involved in the Second World War Dunkirk evacuation.

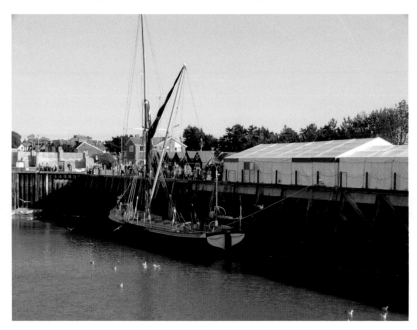

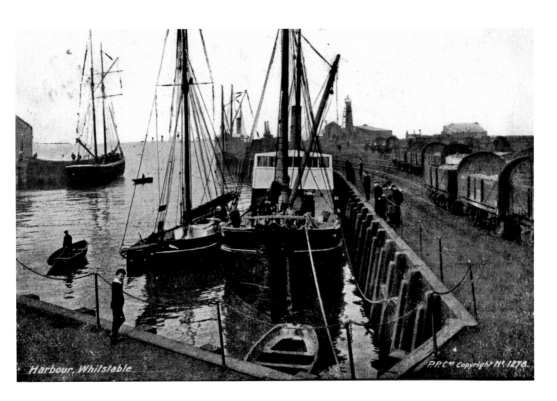

Harbour, Whitstable

P.P.Cᵒˢ Copyright Nº 1278.

Boats and Trains

A busy Whitstable Harbour scene in the early twentieth century. Goods wagons await their next loads in the sidings. As motor cargo ships replaced sail and steam and demand for road building materials increased, London & Rochester Trading Company introduced regular sailings to and from Whitstable. Their vessel *Resurgence* unloads in the harbour in 1963.

The 'Hoos' in the Swale

Lapthorn's 'Hoo' coasters were regular callers into Whitstable Harbour up until the 1990s as demand for road-building materials increased. One of the newest was *Hoo Finch*, 1988/794grt. Sold to Coastal Bulk Shipping and renamed *Fulmer* in 2006, she has since moved on to Greece. Her long modern appearance contrasted notably with that of her smaller predecessor, the 1964-built *Hoofinch*, purchased by Lapthorns as the 322grt *Springfinch*.

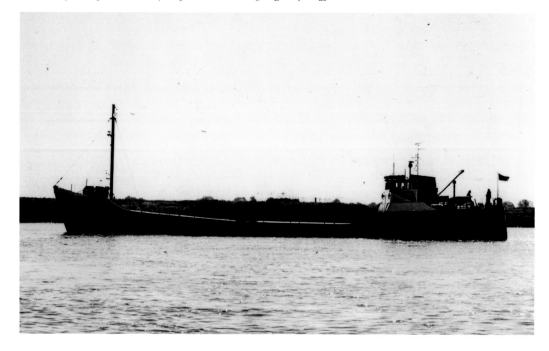

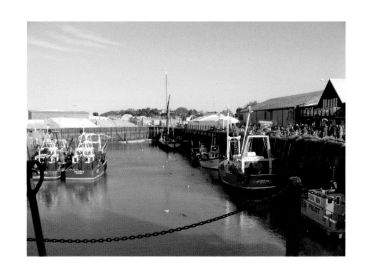

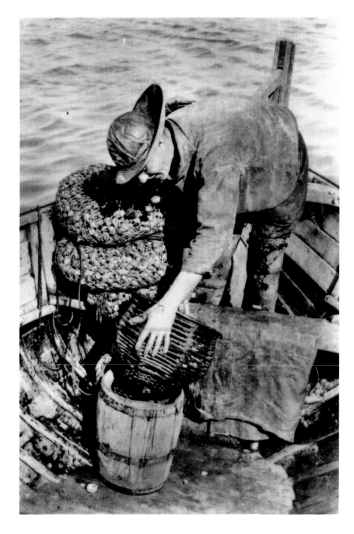

A Good Catch
A whelker hard at work off
Whitstable in the days when
shellfish stocks were plentiful. As
business recovers, motor-powered
fishing boats are a regular feature
of Whitstable Harbour.

Acknowledgements

Much of the material used for the compilation of this book came from my personal sources, but I do wish to extend my sincere thanks to Brian Sherlock of London Thamesport for providing images of the Thamesport terminal and its shipping, to Trevor Edwards for allowing the reproduction of his pictures of Sheerness Dockyard and the Swale bridge and to my daughter Rebecca for expertly shooting colour photographs.

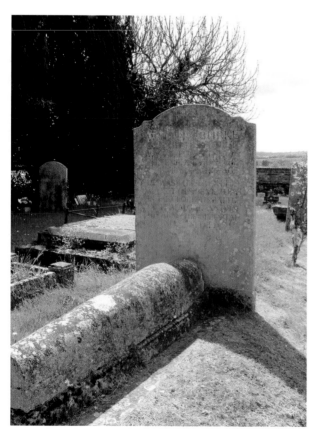

His Fame Lives On
As Lord Nelson lay dying on board HMS *Victory* at the Battle of Trafalgar, his body was cradled by the ship's purser, Walter Burke. Fame and glory were poured upon Burke, who moved to Wouldham where he died on 12 September 1815, aged 70. He was buried in the churchyard of Wouldham's All Saints Church and every year on Trafalgar Day local schoolchildren lay flowers on his grave.